AN AMERICAN VIEW

MASTERPIECES FROM THE BROOKLYN MUSEUM

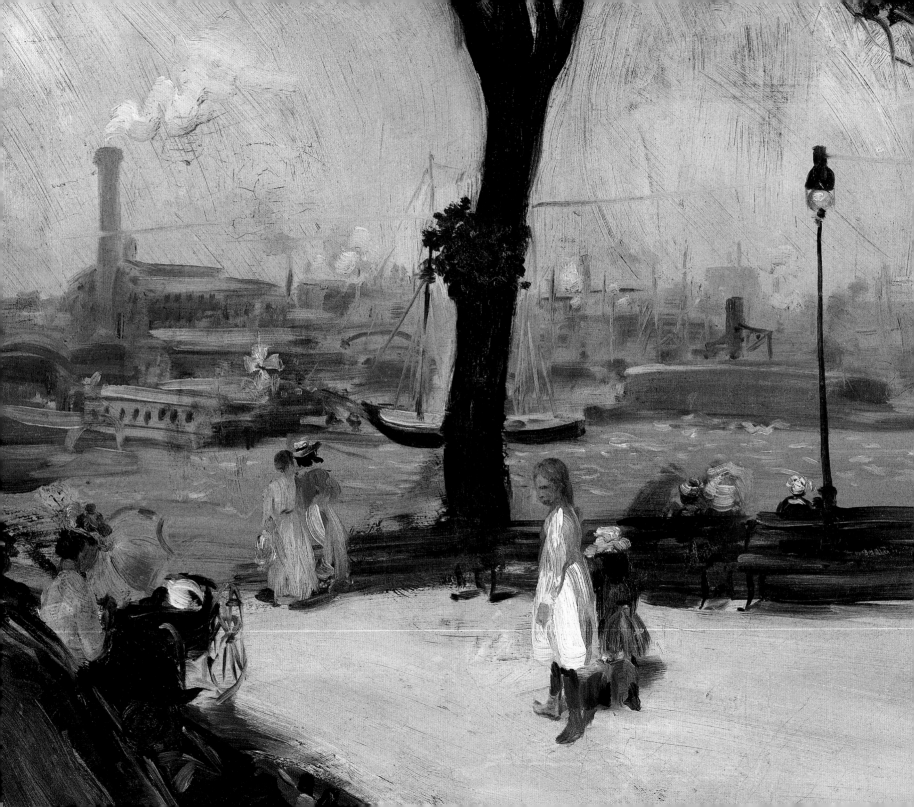

AN AMERICAN VIEW

MASTERPIECES FROM
THE BROOKLYN MUSEUM

Teresa A. Carbone

Brooklyn Museum
in association with D Giles Limited, London

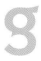

Copyright © 2006 Brooklyn Museum,
200 Eastern Parkway, New York 11238-6052
First published in 2006 by GILES
An imprint of D Giles Limited
57 Abingdon Road, London w8 6AN, UK
www.gilesltd.com

ISBN paperback: 0-87273-154-5
ISBN hardback: 1-904832-11-3

All measurements are in inches and centimeters; height precedes width.

This publication was organized at the Brooklyn Museum.
James D. Leggio, Head of Publications and Editorial Services
Editor: Joanna Ekman
Proofreaders: Fronia W. Simpson and Polly Cone

For D Giles Limited:
Proofread by Moira Johnston
Designed by Helen Swansbourne, London
Produced by GILES, an imprint of D Giles Limited, London
Printed and bound in Singapore

Front cover: John Singer Sargent, *An Out-of-Doors Study* (also known as *Paul Helleu Sketching with His Wife*) (detail), 1889 (p. 118)
Back cover: Winslow Homer, *In the Mountains* (detail), 1877 (p. 94)
Frontispiece: William J. Glackens, *East River Park* (formerly *Park on the River*), circa 1902 (p. 136)

Library of Congress Cataloging-in-Publication Data

Brooklyn Museum.
An American view: masterpieces from the Brooklyn Museum / Teresa A. Carbone.—1st ed.
 p. cm.
Includes bibliographical references and index.
ISBN 0-87273-154-5 (pbk. : alk. paper)—ISBN 1-904832-11-3 (hardcover : alk. paper) 1. Painting, American—Catalogs. 2. Painting—New York (State)—New York—Catalogs. 3. Brooklyn Museum—Catalogs. I. Carbone, Teresa A. II. Title

ND205.B667 2006
759.13'074'7471—dc22
 2005013524

Contents

Foreword

I AM DELIGHTED TO INTRODUCE THIS VOLUME OF masterpieces selected from the Brooklyn Museum's renowned collection of American paintings. This book is being published in tandem with the landmark two-volume scholarly catalogue of the Museum's extensive holdings of American paintings from the eighteenth, nineteenth, and early twentieth centuries. Together these volumes celebrate one hundred and fifty years of commitment to the connoisseurship and study of American art at the Brooklyn Museum, and they signal our institution's enduring dedication to the field and to the broad accessibility of its collections. These publications coincide with the completion of Brooklyn's Luce Center for American Art, where the majority of the superb paintings featured in this volume are regularly on view.

The Museum's exhaustive American paintings catalogue project was made possible through the generous assistance of many friends and sponsors. Foremost among these benefactors is The Henry Luce Foundation. Additional major sponsorship was provided by the National Endowment for the Arts; The Overbrook Foundation; The Kress Foundation; and the late Vance Jordan. I additionally want to thank the Gilbert and Ildiko Butler Foundation, David Schwartz Foundation,

Coe Kerr Gallery, and The Gilder Foundation. At the Museum, the catalogue project was led and completed by Teresa A. Carbone, Andrew W. Mellon Curator and Chair of American Art, with assistance from her colleagues Linda S. Ferber and Barbara Dayer Gallati. I offer my sincere thanks to our contributors and to all Museum staff who participated in the creation of these publications.

For the ongoing support of the Museum's Trustees, we extend special gratitude to Robert S. Rubin, Chairman, and to every member of our Board. Without the confidence and active engagement of our Trustees, it would not be possible to initiate and fulfill projects exemplified by *An American View: Masterpieces from the Brooklyn Museum* and *American Paintings in the Brooklyn Museum*. These volumes mark a milestone in the history of this great collection, mapping its origins, evolution, and current shape, and suggesting its exciting prospects for the future.

Arnold L. Lehman
Director
Brooklyn Museum

Fitz Hugh Lane,
*Off Mount Desert
Island* (detail), 1856

Acknowledgments

This catalogue of american masterpieces from the Brooklyn Museum collection—based on the exhaustive American paintings catalogue that is being published simultaneously—is the product of generations of effort. First, we must thank the collection builders and caretakers who initiated the documentation of the remarkable body of objects that we have the privilege to study and display. In the production of these volumes, we have also relied on the expertise and energies of numerous colleagues and coworkers, at the Museum and in the field, to whom we offer our deepest appreciation.

We owe a debt of gratitude to the Museum's past and present administrations for valuing collection documentation projects, and particularly to our director, Arnold L. Lehman, who has been an energetic supporter of the American paintings catalogue project and its goal of enhanced collection accessibility. The project was initiated with a highly progressive grant from The Henry Luce Foundation, whose generous support of the Museum's multifaceted programs in the field has been steadfast.

Special acknowledgment is owed to Deborah Wythe, Museum Archivist, whose tireless work in recent years has made a detailed collection history possible. Over the course of this project, a number of remarkable young scholars have shared their energies and talents as researchers, including Andrew W. Walker, Nancy Malloy, M. Elizabeth Boone, Lorraine Kuczek, Vivian Gill, Julie Mirabito Douglass, Sarah E. Kelly, and Margaret Stenz. The late Joan Blume, a department volunteer, contributed her research skills and joie de vivre.

Photography of the collection was directed and executed by Dean Brown, formerly Chief Photographer, and his staff. The production of this book was expertly supervised at the Museum by James Leggio, Head of Publications and Editorial Services. We also thank Sallie Stutz, Vice Director for Merchandising, and Judith Frankfurt, Deputy Director for Administration. An enormous debt is owed to Joanna Ekman, Senior Editor, who skillfully guided the course of the American painting catalogues over many years. Our departmental assistant, Meg Holscher, was instrumental in the final stages of the project. Our publisher, Dan Giles, oversaw the production of these volumes with Sarah McLaughlin, Production Director, and Helen Swansbourne, designer.

As principal author of Brooklyn's American paintings catalogues, I thank my former curatorial colleagues Barbara Dayer Gallati and Linda S. Ferber for their contributions to the two-volume catalogue, including the texts on which eight of the entries here are based. It has long been a goal of the department to present Brooklyn's American collections to as wide an audience as possible, and to that end we invite you to turn the page and begin your tour.

Teresa A. Carbone
Andrew W. Mellon Curator and Chair of American Art
Brooklyn Museum

Frederick Childe Hassam, *Late Afternoon, New York, Winter* (detail), 1900

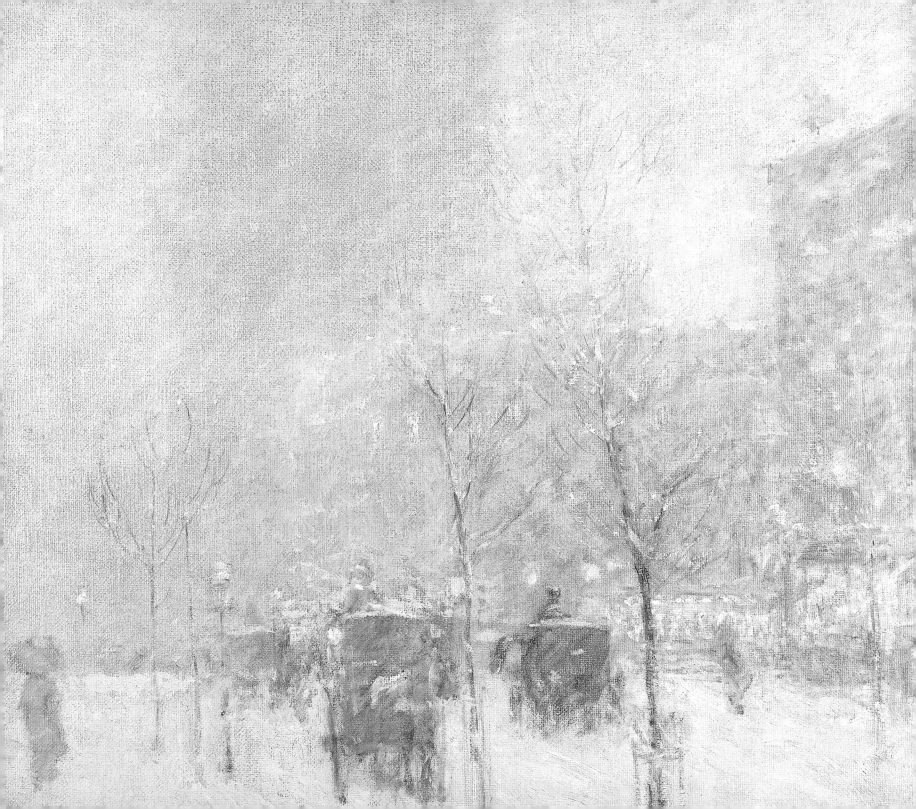

Perspectives on a Collection
Historic American Paintings at the Brooklyn Museum

IN RETRACING THE ORIGINS OF AN AMERICAN CULTURAL institution whose roots are firmly embedded in the nineteenth century, we encounter not only the motives and methods of a distant era, but also the kernel of a philosophy on which a long-lived institution will continue to draw. This certainly is the case with the Brooklyn Museum, whose collections were intended from the outset as a source of enrichment for a broad and diverse popular audience. As the Brooklyn Museum's founding collection, American art has played a defining role in its long history. The American painting collection originated in the 1850s through a singular and highly progressive bequest of funds to commission works by living American painters for the new public galleries of The Brooklyn Institute, the forerunner of the Brooklyn Museum. The bequest was made by Augustus Graham (1775–1851), an Institute founder and leading philanthropist who, under the pervasive influence of antebellum social reform and cultural uplift movements, guided the Institute toward an optimistic embrace of art in the service of social improvement that would endure into the twenty-first century.

The Brooklyn Institute was the only institution of its time known to have commissioned works from living American artists in order to build a permanent collection. Graham's progressive agenda for the visual arts would not have emerged so forcefully without the strong influence of his fellow Brooklynite and ardent reformer Walt Whitman, who vocally advocated for art in the lives of ordinary Americans. During the heyday of the Institute in the 1840s and into the 1850s, Whitman wrote and spoke of American art not only as a vehicle of empowerment for the working classes, a means for their self-improvement and self-expression, but as a conduit for an idealism that might ultimately alter the course of the nation. Given Graham's overarching religious preoccupations and Whitman's personal radicalism, their joint advocacy of a role for art within a reformist institution was remarkably fortuitous. The depth and coincidence of their commitment to art in the lives of the aspiring working class brought about a unique and highly progressive episode in American museum history.

It would be left to a later generation, newly attuned to the value of art in a democratic society, to revive the commitment to American art at the Brooklyn Museum with great success at the turn of the century. The Brooklyn Museum's historic American painting collection was reborn and grew to full flower over the course of a second era that began with the creation of a new museum for Brooklyn in 1897. This is not to say that the mandate established by the Graham bequest for collecting in the field was resumed automatically and maintained continuously to the present day; collections

rarely follow so clear and continuous a trajectory. The rich and comprehensive holdings that today distinguish Brooklyn's collection as one of the finest in the world were, rather, the product of a more circuitous evolution, whose twists and turns offer a distinctive and complex story of acquisitions, exhibitions, and installations over the course of more than a century.

As was the case for most American art museums founded in the late nineteenth century, the first two decades of the twentieth century were years of new and vigorous expansion for Brooklyn's collections, as donors of objects and funds enthusiastically embraced collection building. Donors to museums frequently offered objects and attempted to initiate collecting agendas that did not necessarily accord with goals outlined by trustees and curators. Brooklyn's early acquisitions in American paintings were no exception, following a haphazard course that yielded a young collection inclusive of diverse periods and divergent styles. What nevertheless became clear was the Museum's receptivity to American art at a time when most major American museums were intensely focused on European or Asian art. From 1914 through 1934, under the effective direction of William Henry Fox, the Museum actively pursued an even more unusual exhibition and acquisition agenda in the field of contemporary American art and simultaneously led collecting in the early American field with the guidance of an interested group of scholar-trustees.

The Brooklyn Museum's historic American painting collection attained its critical mass and now widely acknowledged excellence during the tenure of John I. H. Baur from 1936 to 1951. Facing administrative resistance to his acquisition proposals in the field of American Scene painting or Regionalism, Baur instead set out to transform Brooklyn's holdings into a leading survey collection of historic American oil paintings. He astonishingly reached his goal within a decade, resourcefully and creatively securing a significant number of works at a moment of notable inactivity in the American field at many other museums. Baur had an exceptional ability to identify eighteenth- and nineteenth-century American artists worthy of revival and to locate caches of long-forgotten paintings, and both efforts yielded a remarkable number of the collection's masterworks.

By the 1960s the market for American premodern painting had begun to show new signs of vigor—a development that posed fresh challenges for curatorial collecting. As prominent galleries increasingly showcased important works by major American artists, museums encountered new competition from ambitious and more informed private collectors. The Brooklyn Museum nevertheless succeeded in adding a large and wide-ranging selection of paintings from the eighteenth, nineteenth, and early twentieth centuries to the collection, improving both its depth and its quality.

The field of American art was a vastly changed discipline by the 1970s, even compared with just a decade earlier. Over the course of the sixties, a new generation of art historians had begun to make American art their academic specialty. More effectively researched and conceptually complex histories of American art were being written, documenting individual oeuvres and investigating broader trends, and more collections of American art were on view in carefully constructed survey installations. As the new generation of Americanists took their places in curatorial positions,

Raphaelle Peale, *Still Life with Cake* (detail), 1822

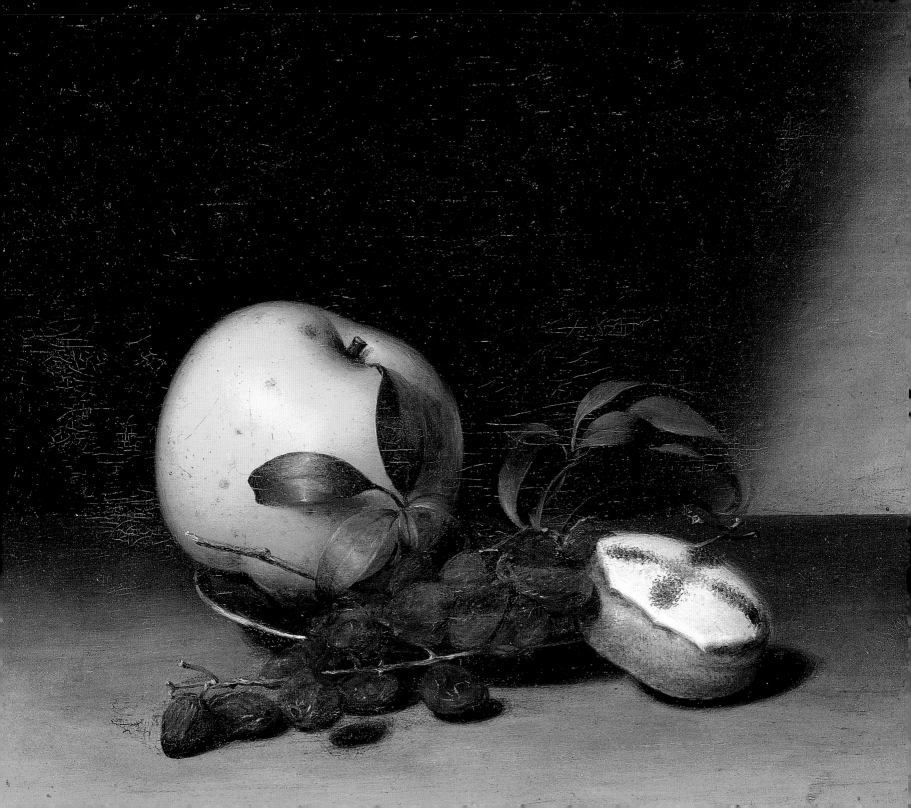

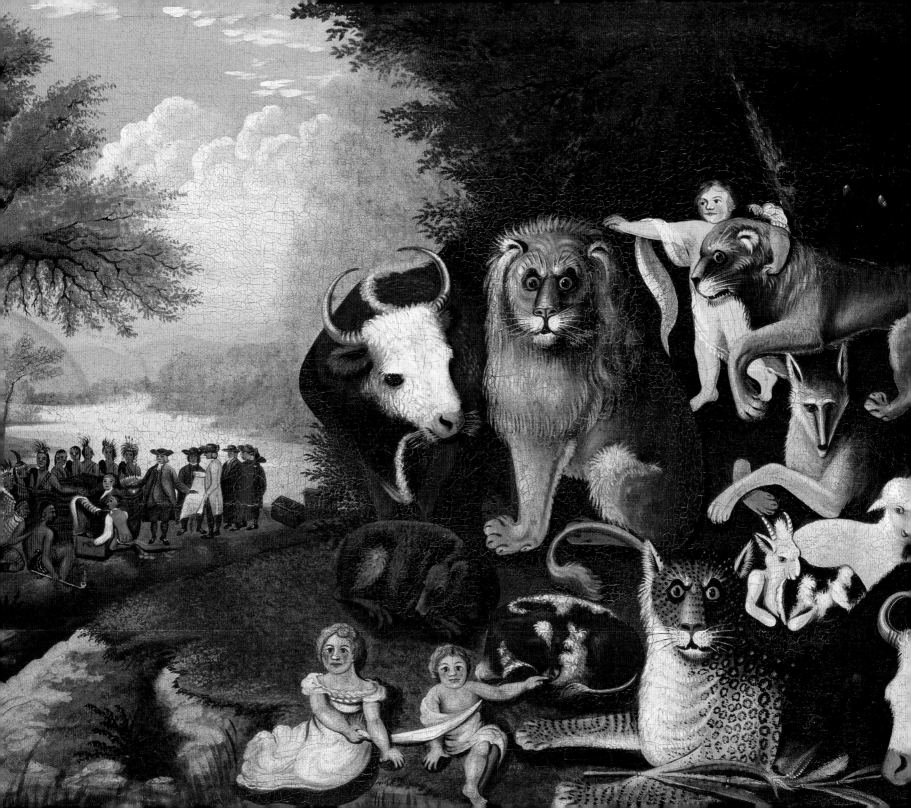

museums increasingly tailored the growth and shaped the display of their American collections in response to academic revisionism. The canon of relevant artists was gradually broadened, and contextual, cultural perspectives were employed to reframe these expanded surveys for the public. Having long led the way in American acquisitions and installations, the Brooklyn Museum has continued to make an impact on the field. Throughout the last quarter of a century, Brooklyn's collection has also grown as the result of important gifts, many of which were inspired by the Museum's historic role in the development of collecting in the field of American art.

Brooklyn's outstanding holdings of historic American painting are now installed in the Museum's Luce Center for American Art. The center includes an expansive installation of the galleries entitled *American Identities: A New Look*, in which historic paintings and sculpture have been combined in a rich, thematic arrangement with a wide array of decorative arts, as well as Native American, Spanish colonial, and contemporary art from the permanent collections. Adjoining the galleries is the Visible Storage • Study Center, which houses 1,500 additional objects in a dense display that offers a sense of the true depth of the Museum's American art holdings.

Today's collection caretakers, academics, and museum visitors approach museum collections with newly critical curiosity about their origins and growth. From our early twenty-first-century perspective, collections are no longer considered simply as well-balanced and carefully arranged historical surveys, but are viewed more correctly as idiosyncratically grown bodies of objects, imprinted with the cultural and aesthetic biases of those individuals most influential in shaping them. Collection histories emerge slowly, through the process of re-embedding their growth in the context of ever-shifting social imperatives, economic fortunes, and changes in taste and public response. The history of Brooklyn's historic American painting collection will continue to be made, and studied, as the priorities of the twenty-first century impress themselves on the current and future generation of stewards at the Museum. Few institutions have so rich and progressive a past in the field of American art on which to build. The very depth and diversity of these holdings and history inspire forward movement—in collecting, interpretation, and display—in a spirit responsive to the accomplishments of the past one hundred and fifty years.

Edward Hicks, *The Peaceable Kingdom* (detail), circa 1833–34

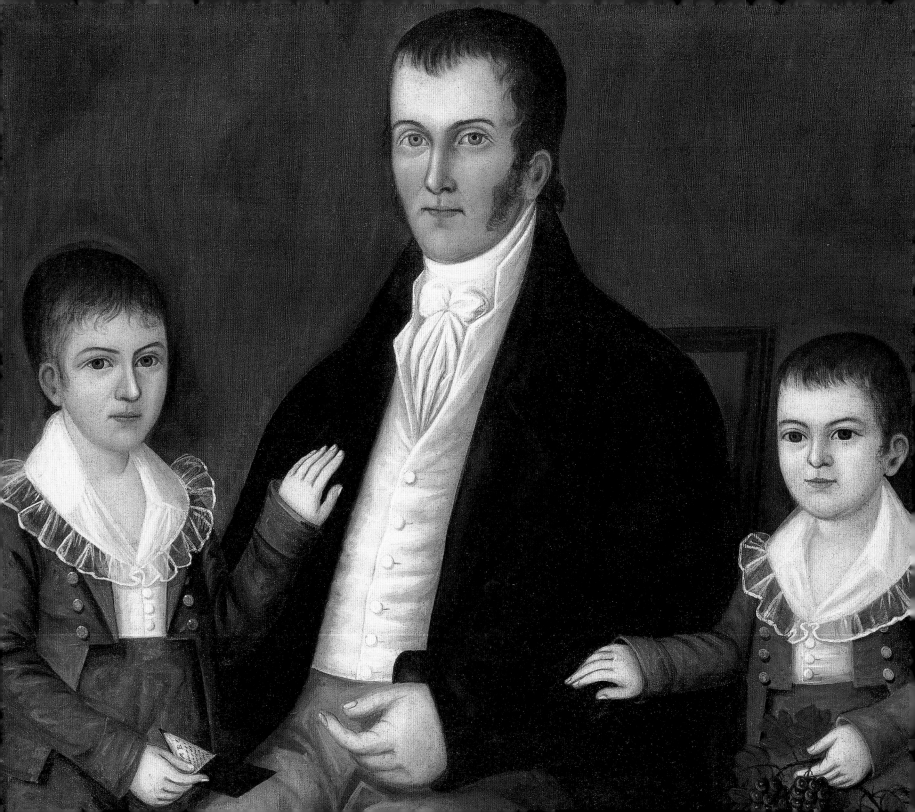

First Impressions
Early American Art

THE FACES WE ENCOUNTER IN THE FIRST SECTION OF THIS BOOK suggest the parameters of the art of painting in the American Northeast from the colonial period into the first decades of the nineteenth century. Without question, portraiture was nearly exclusively the genre for which artists were in demand until after 1800. Numerous foreign painters and a handful of native-born artists worked as portraitists in the North American colonies throughout the eighteenth century, although the unsteady demand for their services led many to undertake less exalted work as decorative artists and sign painters.

Tailoring their imagery for tastes shaped by seventeenth- and early eighteenth-century British and Continental portraiture, these artists routinely relied on prints after famous likenesses from those traditions for specifics of pose, setting, and attributes. Although painters who had been trained abroad demonstrated greater technical skill, their work—particularly before the 1760s—tended to be highly formulaic and repetitive. Untrained artists who employed the same European models produced portraits enhanced by inventive naïveté. All of these painters shared the common goal of creating images that celebrated and ultimately memorialized the character, the accomplishments, and, above all, the social standing of their sitters in colonial society.

By the latter half of the eighteenth century, leading cultural centers including Boston and Philadelphia could sustain the careers of portrait artists. By this time the exceptionally gifted colonial-born painters Robert Feke and John Singleton Copley had originated distinctive portrait manners, in which attention to the materiality of flesh and fabric signaled an increased sophistication of colonial artistic skills and public taste. Copley in particular had an unparalleled impact on colonial painting in the Northeast before his permanent departure for England, dramatically raising the expectations of the portrait-buying audience with likenesses that were highly and expressively individualized, and thoughtfully detailed with exquisite illusionism.

Copley's most prominent successors, including Charles Willson Peale and Gilbert Stuart, were distinguished for having received artistic training in England. Schooled in technique and pictorial conventions, they returned home capable of casting American likenesses in grander formal arrangements based on current portrait fashions, and thus permanently altered notions of portrait painting in Federal-era America. Stuart also cultivated an exuberant painterly manner that constituted the primary influence on American portrait art through the 1820s.

By 1800 and throughout the two decades that followed, the art of painting in America was increasingly diversified. In response to the maturing tastes of the young country and inspired by direct contact with British and Continental precedents, new artists of the Federal period experimented with the genres of landscape, still life, and narrative painting. Although these artists and their works remained in the minority while portraiture, sought by an ever more wide-ranging audience, continued to be the most viable of the genres, their more inventive essays prefigured the dramatic and multifaceted flowering of American painting that would occur by 1830.

Detail, ill. p. 31

Unknown artist

Pierre Van Cortlandt, circa 1731

Oil on canvas, 57 × 41⁹⁄₁₆ inches (144.8 × 105.5 cm)
41.151, Dick S. Ramsay Fund

The work of an artist whose identity is no longer known, this ambitious and graceful portrait of the young New Yorker Pierre Van Cortlandt (1721–1814) originally hung in his family's Stone Street mansion in Manhattan, along with the likenesses of his two brothers. Pierre was the great-grandson of Oloff Stevense Van Cortlandt, a soldier with the Dutch East India Company in 1638 and eventually one of New York's five wealthiest property owners. Pierre's grandfather Stephanus was awarded the vast grant of Van Cortlandt Manor (just north of Manhattan), a substantial part of which Pierre inherited in 1748. Trained by his father in business, agriculture, and the affairs of government, he established mills and a manor house on the property and became a public servant and an active proponent of colonial freedoms.

The artist responsible for the Van Cortlandt portraits sought cues for compositional formulas and pictorial details in popular mezzotints after grand British portraits of the period, here employing prints after Sir Godfrey Kneller's portraits *His Highness the Duke of Gloucester* and *Richard Lord Clifford and Lady Jane His Sister*. Although certain of the borrowed elements were simplified in the process, the colonial artist achieved a remarkable degree of refinement in the precise, if plain, drawing of forms and careful suggestion of gradually modulated light that distinguish the Van Cortlandt portraits from other New York portraits of the period. Here, the decorative curves of the hair and small features are enhanced by the porcelain-like coloration of the face. Among the most pleasingly delicate passages are the effectively simple reflections in the pool and the anatomy of the dog, described by the artist with decorative finesse.

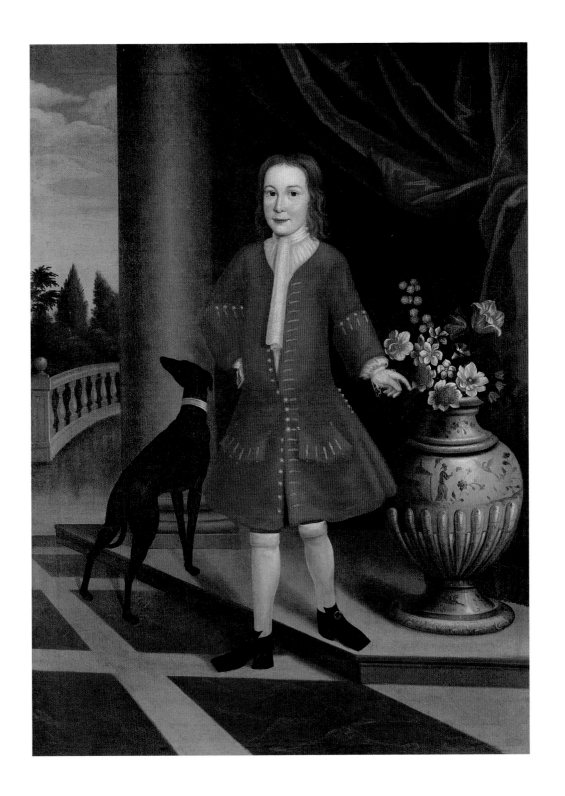

Robert Feke

(circa 1707–1752)

Portrait of a Woman, 1748

Oil on canvas, 49⅜ × 39³⁄₁₆ inches (125.4 × 100.5 cm)
43.229, Dick S. Ramsay and Museum Purchase Funds

This lyrically expressive portrait of an unidentified woman is among the finest works by Robert Feke, the most talented American-born portraitist at work in the colonies before John Singleton Copley. Surprisingly, the early history of this ambitious likeness became clouded by the late nineteenth century, and until 1930 the portrait was considered to be from Copley's hand. Now firmly associated with the high point of Feke's career about 1748, it is set apart from the artist's other three-quarter-length female likenesses by the figure's assertive, standing pose and daringly open, upturned hand.

The disposition of figure and setting, including the rather elaborate landscape backdrop, demonstrates a reliance on British portrait models. The character of certain details and the execution, however, are quintessentially Feke's. Signature elements include the delicate, funnel-shaped torso, large broad eyes, and strong nose, and the carefully graduated modulation of flesh tones from areas of deep, rose-colored shadow to the bright highlights on the forehead, eyelids, and breast. This work is also distinguished by a particularly fine and elaborate finishing of the costume details, most noticeably in the individualized folds and creases of the satin gown and in the precise but fluidly described lace border. Feke's attention to such illusionistic description of fabrics and flesh would prove to be among the strongest stylistic influences on Copley's early works.

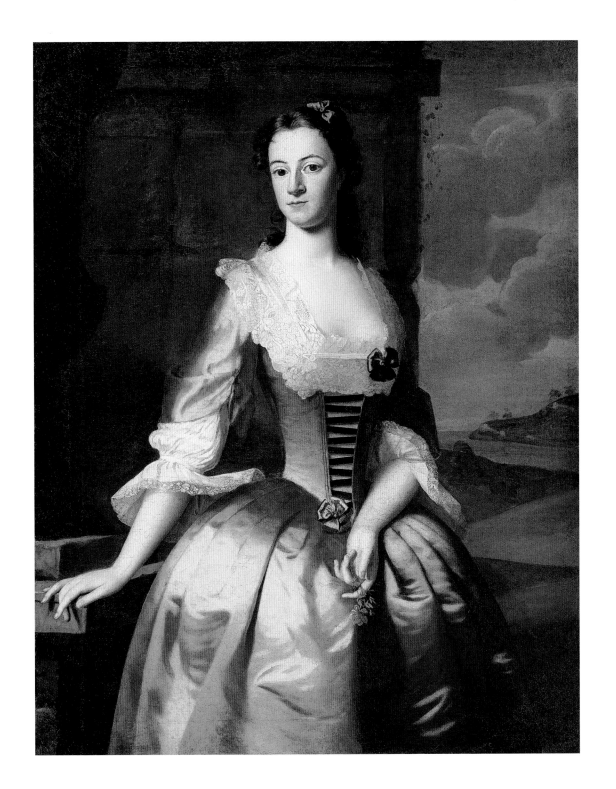

William Williams

(June 14, 1727–April 27, 1791)

Deborah Hall, 1766

Oil on canvas, 71⅜ × 46⅜ inches (181.3 × 116.8 cm)
Signed lower left: "Wm. Williams 1766"
42.45, Dick S. Ramsay Fund

William Williams pursued almost all areas of the artist's profession as it was practiced in the late eighteenth century, working not only as a portrait, landscape, history, and sign painter, but as a gilder and restorer as well. His portrait of the fifteen-year-old Deborah Hall (1751–1770), often considered among the most pleasing and complex portraits of the colonial era, was one of three likenesses presumably commissioned by the sitter's father, the Philadelphia printer David Hall, at the moment he ended his partnership with Benjamin Franklin in order to establish his own firm.

The portrait is rich in symbolic elements that support a reading of this young girl as a personification of the rose, a symbol of love and beauty. Presented here among flowers that have been cultivated in an enclosed garden—a setting long associated with both the goddess Venus and the Virgin Mary—Deborah has been raised within a protective family circle and cultivated for her marital role. The girl and the flower she fingers are linked again through the delicate pink color of both the rose's petals and Deborah's fashionable open-robe gown. The themes of romantic love and chastity are reiterated in the low relief on the stone plinth, which displays the Greek god Apollo's pursuit of Daphne, who escapes his amorous advances by metamorphosing into a laurel tree. The squirrel, a popular pet at the time, was also understood as an emblem of diligence and patience, other qualities for which Deborah would be valued by suitors.

John Singleton Copley

(July 3, 1738–September 9, 1815)

Mrs. Sylvester (Abigail Pickman) Gardiner, circa 1772

Oil on canvas, 50⅜ × 40 inches (128 × 101.6 cm)
65.60, Dick S. Ramsay Fund

The greatest portraitist of the colonial era, John Singleton Copley established his reputation with a body of work executed for Bostonians of all political stripes before his permanent departure for England in 1774. Copley's portrait of the wealthy matron Abigail Pickman Gardiner (1733–1780), very likely commissioned to mark the sitter's 1772 marriage to the Boston landowner and London-trained physician Sylvester Gardiner, demonstrates the artist's significant ties to Boston's community of British Loyalists. The likeness embodies the grander, high-style alternative to Copley's more rigorously factual portraits and is distinguished by a fluid elegance and vernal palette.

In contrast to his portraits of bibbed and white-capped colonial ladies in interior settings, this work includes a formal landscape backdrop and its sitter is costumed in an exotic robe "à la turque," a manner of Turkish-inspired dress that was highly fashionable at English and French masquerades of the period. This flamboyant and uncorseted style, which would have been considered improper for public use in colonial American society, appears to have been an invention preferred by Copley for sitters who aspired to the height of British fashion and the social status it implied. His direct record of Mrs. Gardiner's substantial figure would also have been read as evidence of her social station and material wealth. In this portrait, as in his less romanticized likenesses, Copley displayed an uncanny ability to achieve a calculated naturalism through intuitively fluid means. Among the most remarkable passages in this regard are the sitter's hands, where the artist conveyed anatomical details with liquid touches of paint.

Charles Willson Peale

(April 15, 1741–February 22, 1827)

George Washington, 1776

Oil on canvas, 44 × 38⁵⁄₁₆ inches (111.7 × 97.3 cm)
34.1178, Dick S. Ramsay Fund

Philadelphia's leading colonial painter, Charles Willson Peale undertook this first portrait of George Washington as commander in chief of the Continental army on commission from John Hancock, the president of the Continental Congress. Hancock planned the commission at least in part to flatter Washington and to cement his allegiance immediately after the general's successful defense of Boston, and Hancock's extensive properties there, against British troops early in 1776. The two men's relationship had been contentious because Hancock not only replaced Washington's close friend Peyton Randolph as president of the Continental Congress in 1775, but had been eager to seat one of his own allies in the position of commander in chief. Washington consented to give Peale two sittings in May 1776, despite his more pressing concerns.

Peale labored on the portrait well into the fall, recording Washington's imposing stature and the particulars of his military dress (the buff-and-blue uniform and blue sash of the commander in chief). Washington's elongated form ex-hibits the serpentine curve that Peale derived from the theories of the English artist William Hogarth and employed liberally in order to lend his figures a calculated grace; the head is suffused with the heavy shadow of the artist's early manner. Peale placed the figure before a backdrop of Boston Harbor beneath a sky clouded with the dark smoke of battle. The details suggest that the view is to the southeast, with Washington on the heights of Cambridge, from which he had directed the defense against the British that winter.

Peale received payment for the portrait in early December, just days before most Philadelphians evacuated the city as British troops approached, and he then set out to join Washington's army at Trenton, New Jersey. Hancock sought refuge in Baltimore before granting himself a controversial temporary leave from Congress to return to Boston with his household and belongings, under the protection of soldiers grudgingly assigned by Washington. The portrait thus began its long residence in Hancock's elegant stone mansion on Mount Vernon Street.

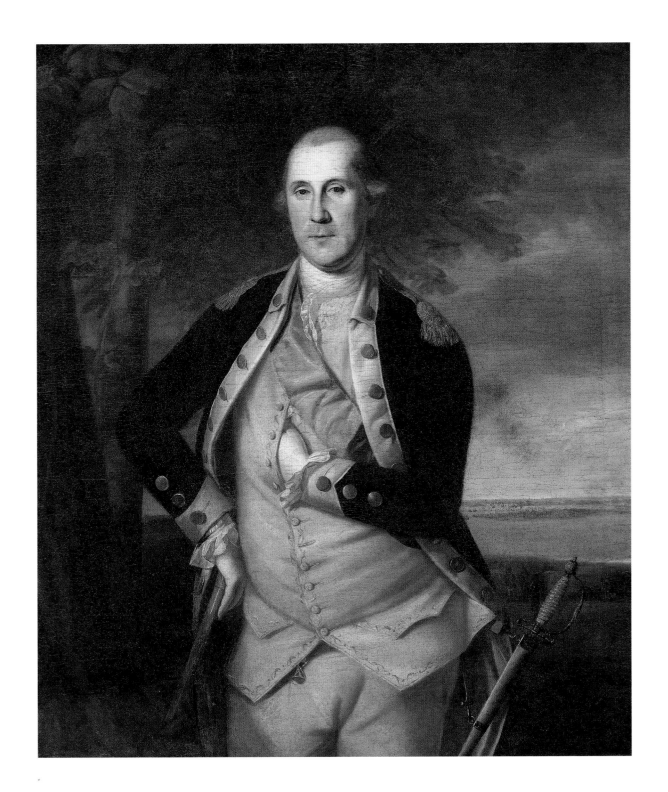

Gilbert Stuart

(December 3, 1755–July 9, 1828)

George Washington, 1796

Oil on canvas, 96¼ × 60¼ inches (244.5 × 153 cm)
45.179, Dick S. Ramsay and Museum Purchase Funds

The master of an exuberantly fluid style that dominated American portraiture from the 1790s well through the turn of the century, Gilbert Stuart is perhaps best known for his many portraits of the country's first president. This important example is one of the three earliest versions of the full-length likeness of George Washington known as the Lansdowne Washington, owing to the fact that the first version (National Portrait Gallery, Smithsonian Institution, Washington, D.C.) was commissioned by the wealthy Philadelphian William Bingham for presentation to Lord Lansdowne (William Petty, also Lord Shelburne), the British prime minister who presided over the peace talks with the colonies in 1782. Bingham had Stuart paint a replica to retain for himself. Brooklyn's version was commissioned in 1796 by the wealthy Irish-born New York merchant and landowner William Kerin Constable, a former Continental army officer and an ardent supporter of Washington. According to his daughter, Anna Maria Pierrepont, Constable visited Stuart in Philadelphia in 1796 to sit for his own portrait and, on seeing the Lansdowne picture in progress, requested that Stuart simultaneously execute a second version.

Stuart conceived the portrait in the Grand Manner in order to demonstrate his superior talents and to create a fitting representation of Washington as preeminent statesman. He based the portrait head on his 1796 life study known as the Athenaeum Portrait (National Portrait Gallery, Smithsonian Institution, Washington, D.C., and Museum of Fine Arts, Boston), and for the disposition of the figure and other compositional details, he relied heavily on Pierre-Imbert Drevet's 1723 engraving after Hyacinthe Rigaud's Baroque portrait of Bishop Jacques-Bénigne Bossuet. Set in a pose long associated in art with the persona of the orator, Washington appears in formal civilian dress but holds a sword that recalls his military achievements and suggests the might of his presidency. The setting includes ornate Neoclassical-inspired furniture, whose details were derived from the Great Seal of the United States, as well as several volumes (*American Revolution, Constitution and Laws of the United States,* and *The Federalist*) that speak to Washington's accomplishments, ideals, and politics. Stuart painted a rainbow in the distant sky as a symbol of the peace after the storm of the Revolution and possibly of more recent political conflicts.

In 1812 William Constable sold the painting to his son-in-law, the prominent Brooklynite Hezekiah Beers Pierrepont, in whose home it was hanging in 1824, when General Lafayette viewed it during his visit to Brooklyn. The Museum purchased it from the Pierrepont family in 1945.

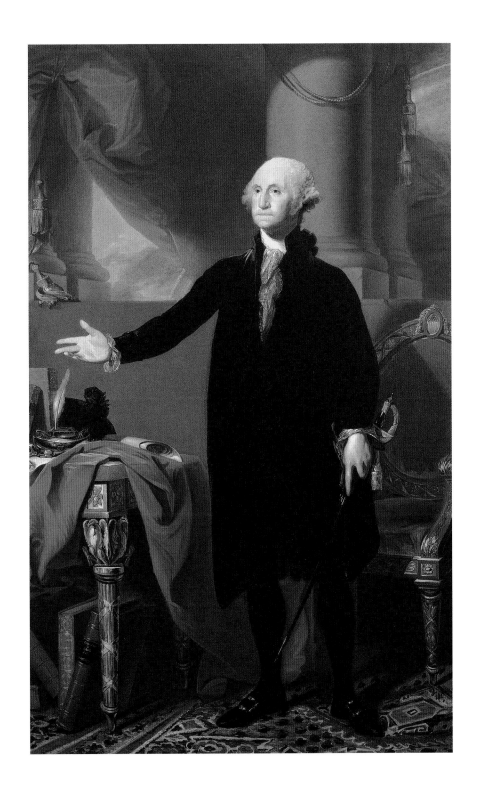

Joshua Johnson

(active circa 1795–circa 1825)

John Jacob Anderson and Sons, John and Edward, circa 1812–15

Oil on canvas, 30⅛ × 39¹¹⁄₁₆ inches (76.5 × 100.8 cm)
1993.82, Dick S. Ramsay Fund and the Mary Smith Dorward Fund

The African American portraitist Joshua Johnson successfully passed his entire career in the tolerant environment of Baltimore, where in 1800 one-fifth of the population was black and one-quarter of all blacks were free. Johnson's sitters for this simply but delicately rendered group portrait were the Baltimore grocer John Jacob (?) Anderson and his two young sons, John (circa 1809–?), on the left, and Edward (circa 1811–?), who appear to have resided in the same neighborhood as the artist. Johnson based his portrait manner on those examples to which he had access, including the works of his putative mentor Charles Willson Peale and those of the latter's nephew Charles Peale Polk.

This work exhibits the crisp drawing and soft palette typical of Johnson's prolific second period (1803–1813/14), as well as the ovoid heads (probably derived from Peale), rather wooden features, and naïvely described hands characteristic of his figures. Johnson developed a reputation particularly for his portraits of children, and here he extended that proclivity to the poignant representation of familial ties. The three figures are tenderly bound as a unit, with the boys each extending an arm to their father and resting a hand on the latter's sturdy form, while their father's open hand suggests his gentle accessibility.

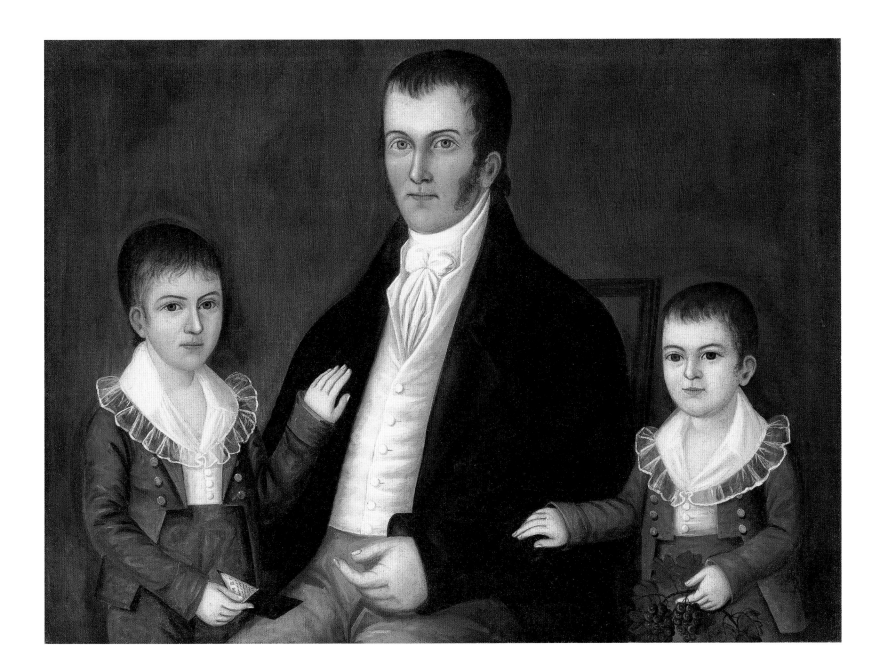

Francis Guy

(1760–August 12, 1820)

Winter Scene, circa 1819–20

Oil on canvas, 58⅜ × 74⁹⁄₁₆ inches (148.2 × 189.4 cm)
Inscribed on sign on fence: "To be Seen / A View / [illegible] / Brooklyn / By / Guy / [illegible]"
97.13, Transferred from the Brooklyn Institute of Arts and Sciences to the Brooklyn Museum

The English tailor-turned-artist Francis Guy, who enjoyed a successful American career as a painter of topographical scenes, completed this remarkable view of "downtown" Brooklyn about 1819. From the time it was first exhibited in 1820, Guy's so-called Brooklyn Snow Piece was considered a marvel of atmospheric effect and engrossing factual detail. According to press reports at the time, Guy took this view from the window of his painting room on Front Street, whose curve he greatly accentuated in order to bring the houses along its outer edges into view. He very likely intended to contrast the elegant brick residences of Augustus Graham and other newly wealthy Brooklynites (visible in the painting before fire damage led to the trimming of the canvas's left side) with Abiel Titus's "old-fashioned," sprawling Dutch barnyard, which occupies much of the scene's center. The figures, which delighted early audiences, were all based on actual individuals whose identities were recorded in a pamphlet published at the time of the painting's debut.

Contemporary viewers were equally impressed with Guy's expressive description of the wintry, cloud-filled sky.

When its first owner offered the painting for sale about 1846, *Winter Scene* was purchased for the fledgling Brooklyn Institute by a group of interested locals. By this time, the work was well known through the Institute's annual exhibitions, in which it was featured in 1845 and 1846. Shortly thereafter, the young Walt Whitman described the painting for the *Brooklyn Standard*, enumerating its contents in a listlike fashion not unrelated to his early verse and remarking on the contrast it provided to the much-altered Brooklyn of midcentury: "[I]t is a picture of . . . a thriving semi-country cluster of houses in the depth of winter, with driving carts, sleighs, travelers, ladies, gossips, negroes (there were slaves here in those days), cattle, dogs, wheelbarrows, poultry, etc.—altogether a picture quite curious to stand on the same spot and think of now."[1]

1. Walt Whitman, *The Uncollected Poetry and Prose of Walt Whitman*, ed. Emory Holloway (Garden City, New York: Doubleday, Page & Co., 1921), vol. 2, pp. 231–32.

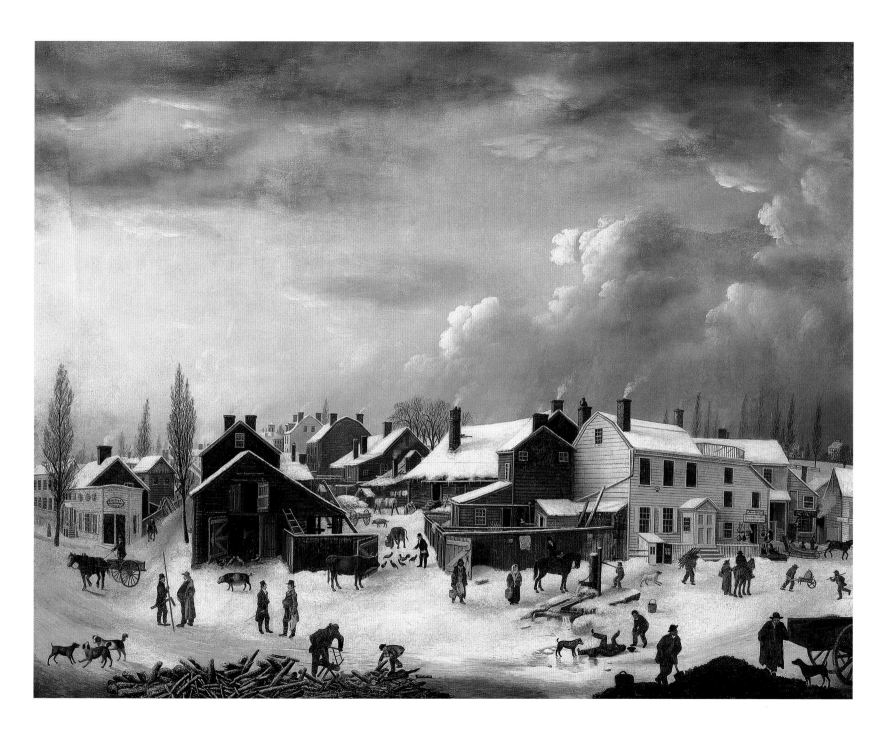

Washington Allston

(November 5, 1779–July 9, 1843)

Italian Shepherd Boy, circa 1821–23

Oil on canvas, 46⅞ × 33⁹⁄₁₆ inches (119 × 85.3 cm)
49.97, Dick S. Ramsay Fund

After his return from a European sojourn in 1818, Washington Allston, the leading proponent of the Romantic sensibility in antebellum American art, devoted his energies to poetic, imaginative subjects, which his American audience accepted more readily than his grand history paintings. In his introspective *Italian Shepherd Boy*, Allston described the pale and vaguely androgynous form of a young boy within the setting of a shadowy, wild landscape, crystallizing the Romantic notion of the child as symbolic of the ideal, precivilized state of cultural development in an untamed natural environment. The contrast between the boy's idealized form and the sublime setting may additionally refer to the thwarted unity between humankind and nature, or even to the artist's own personal dismay about leaving England's welcoming artistic and literary circles for the comparative cultural wilderness of America.

The mood of contemplative melancholy is underscored by the flute that rests unused in the boy's hand and may be read as an emblem of death. The figure in a closely related work of the same title by Allston (The Detroit Institute of Arts) has been linked to the character of Edwin in James Beattie's Spenserian poem, "The Minstrel: or, the Progress of Genius," where he serves as a personification of poetic imagination who dies when he leaves his pastoral environment to enter conventional society. The feminist writer Margaret Fuller, Allston's contemporary, described the figure of the Italian shepherd boy as "lapt in the Elysian harmony" formed by nature. The fact that Allston based the image on much earlier figure studies, executed in Rome about 1804–8, confirms his reliance on memory and imagination in the production of his art.

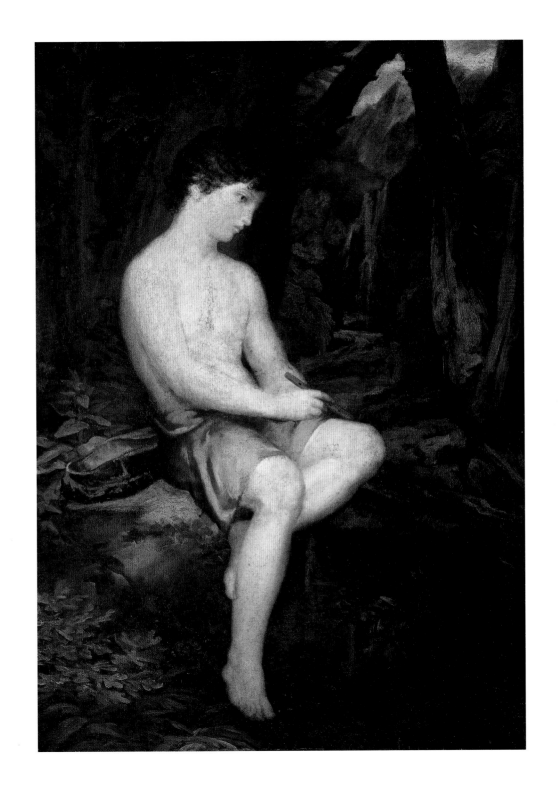

Raphaelle Peale

(February 17, 1774–March 4, 1825)

Still Life with Cake, 1822

Oil on panel, 9½ × 11⁵⁄₁₆ inches (24.1 × 28.7 cm)
Signed lower right: "Raphaelle Peale Jany: 1st. 1822"
24.72, Museum Collection Fund

This modest but intimately suggestive arrangement was among the late works of Raphaelle Peale, the eldest surviving son of the eminent Philadelphia artist-museologist Charles Willson Peale and the first American painter to devote his career primarily to still lifes. For this sober little panel completed and signed on New Year's Day of 1822, Peale chose as his subject a small plate bearing an imperfect yellow apple (the late-ripening "Washington's Favorite"), a sprig of raisins, and a small iced cake known as a Poor Man's Pound Cake—a meager display indicative of both the winter season and the artist's severely humbled circumstances. Peale's specialty in the still-life genre provided him a scant income and frustrated his father, who continually pressed him to abandon it for the more lucrative field of portraiture.

In contrast to Peale's earlier images of larger, sliced cakes, and those that combine the cake motif with an inviting glass of dessert wine, this panel also evokes a sense of solitude and containment rather than hospitality or sociability. The most meaningful edible of the group is the particular type of holiday cupcake, which was made in poorer homes from leftover dough improved with sugar and flavorings like rosewater or nutmeg, baked in small tins or old teacups, and iced and decorated in just this fashion. For Raphaelle Peale, such details may have been a reminder of childhood days when a fond family servant baked him sweets.

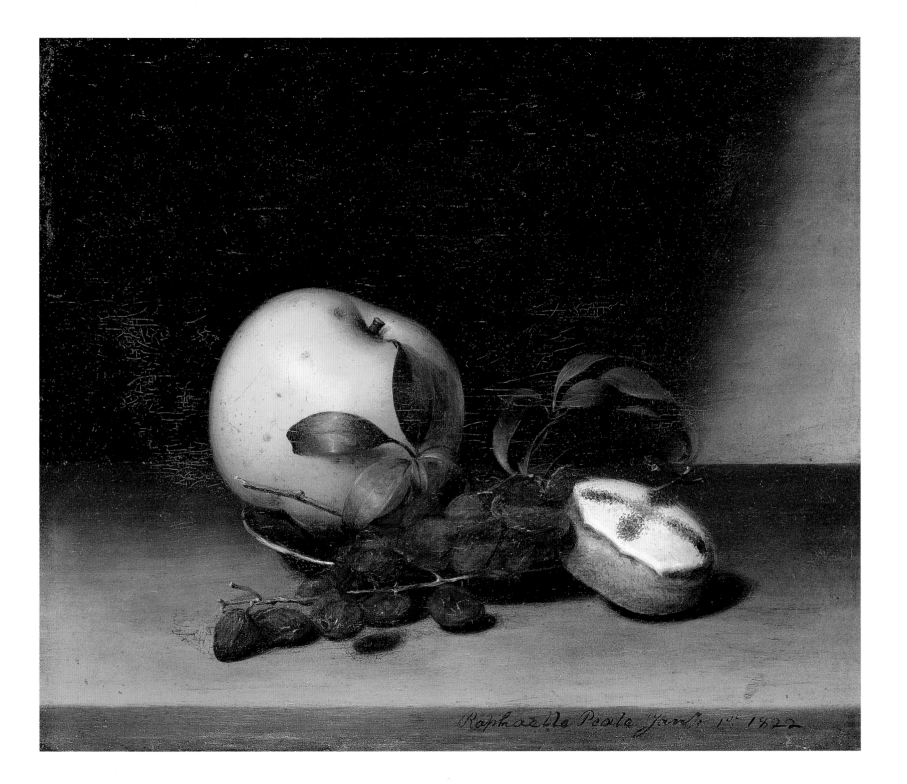

Raphaelle Peale Jan'r 1st 1822

Rembrandt Peale

(February 11, 1778–October 3, 1860)

The Sisters, 1826

Oil on canvas, 42⅛ × 32¹¹⁄₁₆ inches (107 × 83 cm)
67.205.3, A. Augustus Healy Fund B

Rembrandt Peale, one of the sons of the painter Charles Willson Peale, is best remembered for a number of innovative portraits, including this beautifully composed and richly colored record of his daughters Rosalba Peale (1799–1874) and Eleanor Peale Jacobs (1805–1877). The painting is a testament to his abilities, which were largely untapped by his conventional portraits or by the history subjects to which he could devote his attention only intermittently. The work remains his most important addition to the tradition of Peale family portraiture, in which the engaging portrayal of artistic vocation was valued as highly as the physical likenesses of beloved relations. Here delicately linked, the Peale sisters sit before a tapestry-covered table bearing a palette and a volume of scores by "Handel." Both girls had been trained in the family "business," and by the time Peale painted this portrait in 1826, Rosalba, portrayed with a drawing tool, had become her father's loyal artistic right hand.

Peale based the composition on an engraving after George Henry Harlow's painting entitled *The Congratulation*, in which two women share news of one's betrothal. He may initially have found inspiration for this work, however, in the remarkable double portrait of the daughters of Joseph Bonaparte executed by his Parisian role model Jacques-Louis David in 1821. Peale would have had a number of opportunities to see the portrait by David because Bonaparte, the former king of Spain, had taken refuge in America in 1815 and attracted a following of ardent American Francophiles including Peale and his father. The younger Peale indeed appears to have taken a number of cues from the David portrait, including the close linking of the two forms so that each seems half of a whole, and the interplay of familial resemblance and contrasting temperaments in the paired heads. Peale used painstakingly fine brushwork to describe the elongated forms of his elegantly costumed and coiffed daughters, creating a seamless surface and coloristic transitions of studied subtlety. Secure in the magnitude of his achievement, he exhibited the portrait at London's Royal Academy of Arts in 1833.

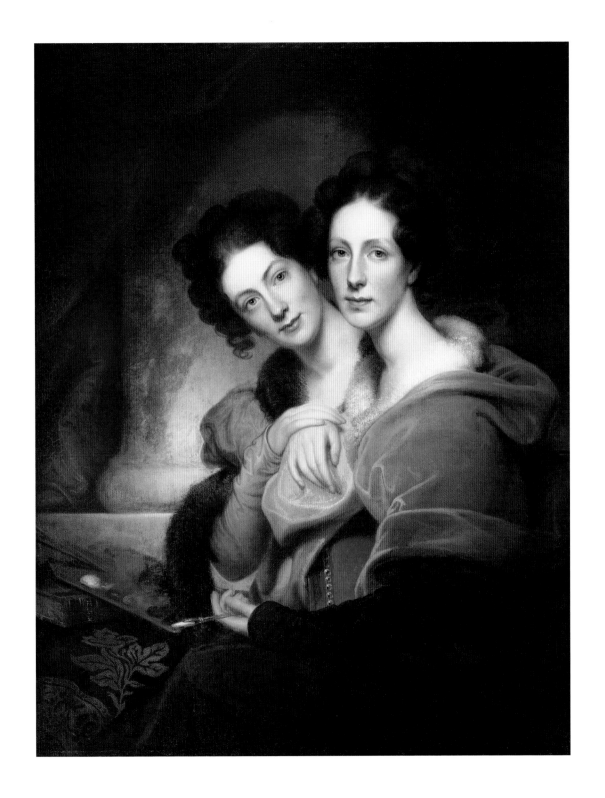

Samuel F. B. Morse

(April 27, 1791–April 2, 1872)

Jonas Platt, 1828

Oil on canvas, 35¹⁵/₁₆ × 29⁷/₁₆ inches (91.3 × 74.8 cm)
85.23, Dick S. Ramsay Fund

Despite the missionary zeal with which he promoted grand, moralizing art in America, Samuel F. B. Morse was forced to rely on portrait work and scientific pursuits to earn his reputation and living. By the mid-1820s his portraits demonstrated a fluid technique and mastery of high color that rivaled the accomplishments of the aging but still revered Gilbert Stuart. This portrait of Jonas Platt (1769–1834) is counted among the most sensitive and finely brushed likenesses dating from the high point of his career.

At the time that he sat for Morse, Jonas Platt, son of the founder of Plattsburgh, New York, was a prominent New York attorney with a successful political career behind him. In 1810, with his fellow state senator DeWitt Clinton, Platt had promoted the passage of a bill proposing the construction of the Erie Canal, a project that promised to enhance the value of his substantial landholdings. This portrait was commissioned by Moss Kent, Platt's former colleague on the New York Supreme Court, who undoubtedly was aware of Morse's own very active role in the same conservative political circles in New York State.

The artist depicted Platt as a decorous, calm, and cerebral man with attributes signifying his reliance on the written word. Morse's coloristic treatment of the subject is more liberated, including his luminously liquid description of the hands. In describing Platt's veined temples and imperfect skin, he achieved a natural illusionism and immediacy that were not present in Stuart's highly fluid but more stylized manner.

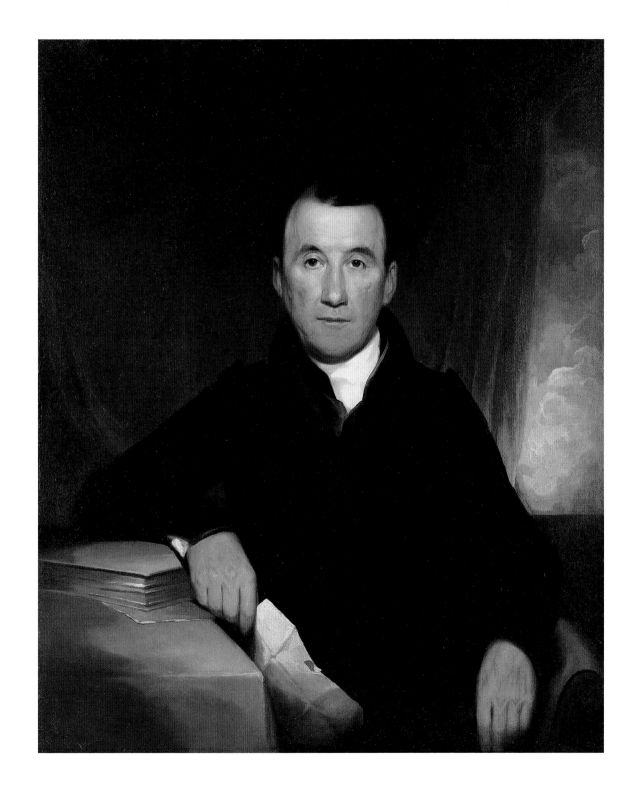

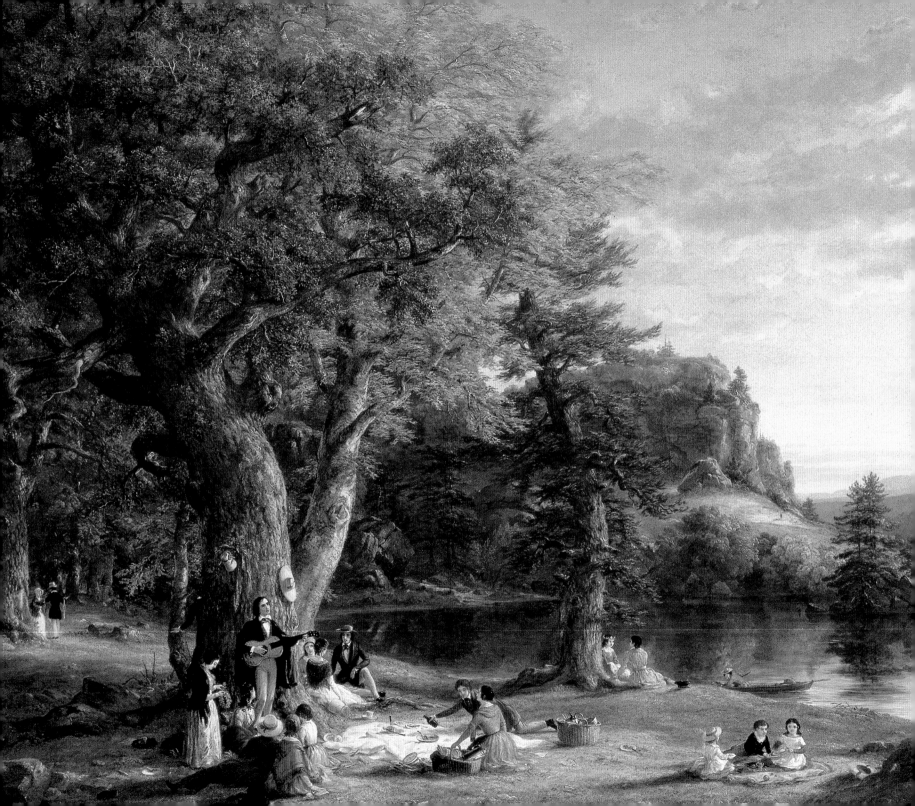

Coining American Subjects
The Antebellum Decades

ALTHOUGH PORTRAITURE WAS SLOW TO RELINQUISH ITS FIRM GRIP on American taste through the 1820s, new practitioners of landscape and narrative painting eventually began to plumb native sites and aspects of American life for fresh subjects indicative of a national character. The works of Thomas Cole and William Sidney Mount were, and remain, the quintessential examples of these new directions: Cole cast the newly fascinating vistas of the American Northeast according to the strictly prescribed conventions of British landscape art, and Mount codified the characters and habits of rural American society in narrative formats established by an equally accessible set of British and Dutch precedents. Other highly imaginative painters sought American subject matter in the freshly minted productions of American writers such as Washington Irving. The most intrepid and ambitious among this generation of artists experimented with historical subjects, drawn from the colonial past, that demanded a more sophisticated set of skills, including a greater facility in large-scale figure painting and the ability to convincingly re-create period details.

Over the course of the antebellum period, a growing number of landscape and genre painters enjoyed an enthusiastic reception of their work, both at public exhibitions of their original paintings and in the lively response to reproductions after the most popular of these images. History painters encountered comparatively stiff criticism from an audience reluctant to embrace the high seriousness of their works and thoroughly resistant to the incorporation of art—other than portraits— into public settings. Such artists simply could not compete with narrative painters willing to tailor their content to the ever-widening taste for anecdotal subjects imbued with popular notions of humor or sentiment. By midcentury these narrative themes expanded to encompass a broader variety of rural incident that included frontier life, as well as more carefully crafted domestic interiors invested with traditional ideals and an increasingly overt moral didacticism. Exceptions such as the more liberated compositions of Lilly Martin Spencer provide an interesting perspective against which to measure the mainstream of domestic subject matter.

Among all the genres of antebellum American painting, landscape was and continues to be perceived as the most original and progressive. Cole's groundbreaking, highly orchestrated compositions—whose grand universal themes of historical cycles and divine providence very likely were lost on many of his viewers—gradually were superseded in the 1850s by landscape imagery more fully immersed in its American setting and freed from the circumscribed formulas of the British tradition of the picturesque. In images both intimate and expansive, midcentury American landscape artists recorded more directly their responses to natural detail and ephemeral conditions, thus providing the viewer with a greater sense of immediacy. The paintings of this period, and landscape works in particular, convey a buoyant sense of national optimism that was to be profoundly altered as the forces of war coalesced.

Detail, ill. p. 53

John Quidor

(January 26, 1801–December 13, 1881)

The Money Diggers, 1832

Oil on canvas, 15¹⁵⁄₁₆ × 20¹⁵⁄₁₆ inches (40.5 × 53.2 cm)
Signed right center: "J. Quidor Pinxt / N. York June, 1832."
48.171, Gift of Mr. and Mrs. Alastair Bradley Martin

A highly unconventional artist by the standards of antebellum America, John Quidor pioneered the use of American literary subjects in such original and expressively delineated paintings as *The Money Diggers*. Here the artist turned to Washington Irving's *Tales of a Traveller* (1824) for the satirical account of a hapless New York Dutchman's pursuit of buried treasure. In the story "Wolfert Webber, or Golden Dreams," a cabbage farmer becomes so obsessed with finding gold buried at the time of the British takeover of colonial New York in the 1660s that he digs up all of his fields, to no avail. Quidor represented the narrative's climax in the subsequent story "The Adventure of the Black Fisherman," when Wolfert and his cohorts "Black Sam" and the German Dr. Knipperhauser begin to unearth a treasure guarded by pirate spirits on the shore of Long Island Sound.

Following Irving's colorful details with surprising exactitude, Quidor contrived the scene in a highly animated composition that must have taken formal cues in part from the caricatured figure subjects of the eighteenth-century British artists George Cruikshank and William Hogarth. He cast the curiously contorted figures in the nervous half-light of the roaring fire and employed a play of sinister highlights to carry their fevered expression into all corners of the scene. The subjects that Quidor drew from Irving are indicative of nineteenth-century New York's fascination with its highly romanticized Dutch origins, the physical evidence of which was fast disappearing. Although his work created a ready caricature of this most long-established and tradition-bound of all the ethnic groups that were coming to make up New York, the descendants of Dutch settlers remained at the very top of the city's increasingly complex social hierarchy.

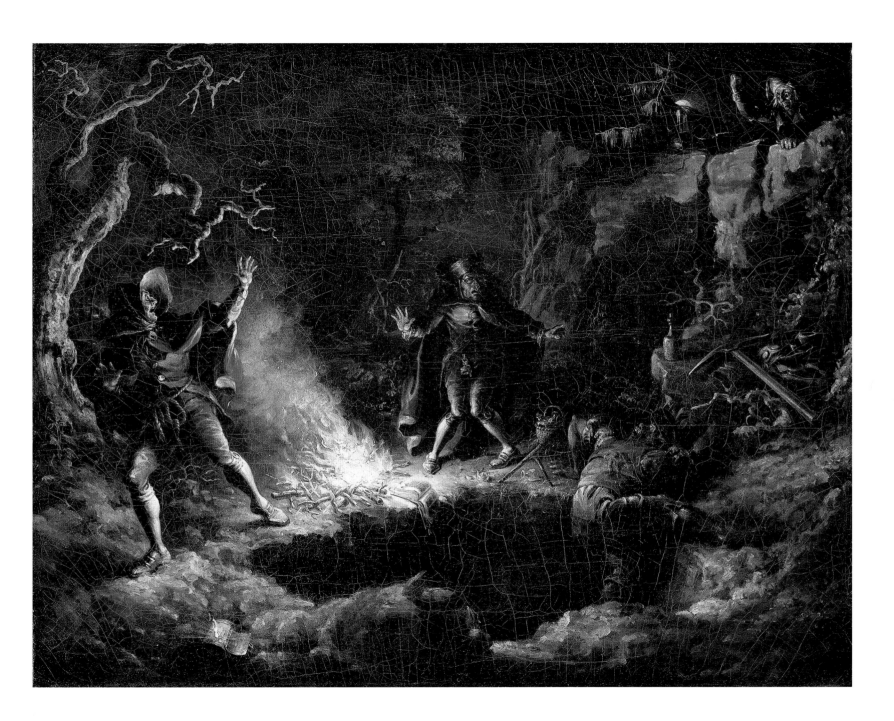

Edward Hicks

(April 4, 1780–April 23, 1849)

The Peaceable Kingdom, circa 1833–34

Oil on canvas, 17⁷⁄₁₆ × 23⁹⁄₁₆ inches (44.3 × 59.8 cm)
40.340, Dick S. Ramsay Fund

From about 1820 the self-taught artist and Quaker preacher Edward Hicks painted approximately sixty versions of *The Peaceable Kingdom*, based on verses from the Old Testament book of Isaiah (11:6–9), in an effort to find a common ground for his ardent faith and his artistic vocation. By the 1830s his treatments of the theme included all of the animals that, according to the scripture, would surrender their wild natures and appetites to an inner spirituality: "The wolf also shall dwell with the lamb, and the leopard shall lie down with the kid; and the calf and the young lion and the fatling together; and a little child shall lead them." The verses had particular significance for pacifist Quakers, and for Hicksite separatists (led by the artist's cousin Elias Hicks), who held that spiritual birth occurred only through the surrender of the individual will to the "Inner Light" from God.

The Hicksites, who understood the Bible as allegory, maintained that bears, leopards, lions, and wolves—and the people they symbolized—could strive only to attain the enlightened innocence of the lamb, kid, cow, and ox. Hicks placed the paired animals in a ring around the straw-eating lion and ox. Brooklyn's version additionally includes a prominent vignette of "William Penn's Treaty with the Indians," in recognition of the artist's allegiance to the earliest Quaker founders in America. In his easel paintings Hicks maintained the naïve manner of his ornamental work in response to Quaker objections to fine art, which was considered perniciously nonutilitarian and idolatrous in its realism.

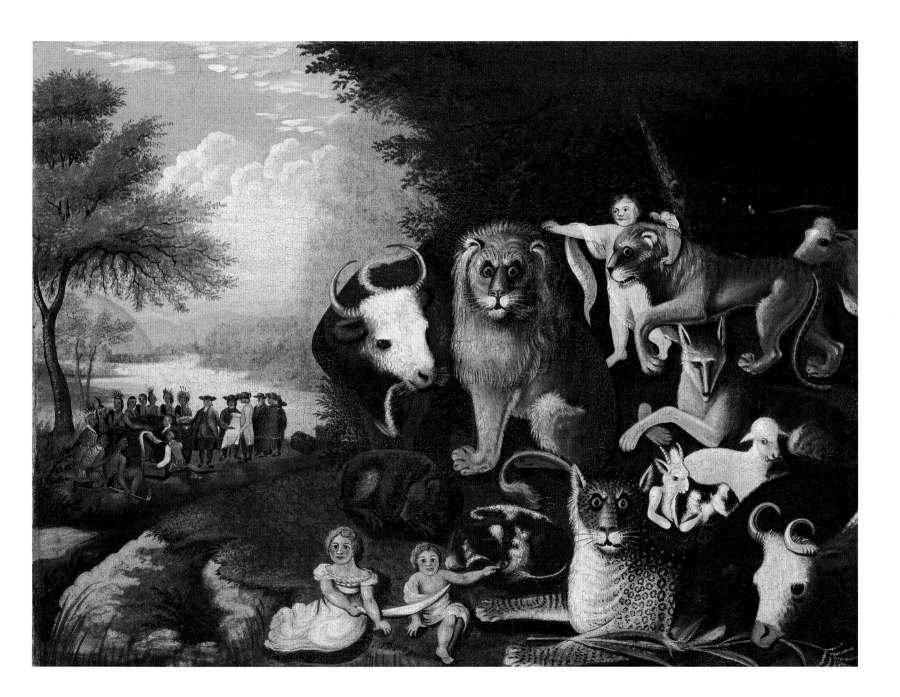

Ammi Phillips

(April 24, 1788–July 11, 1865)

Mrs. John Vincent (Jeannette E. Woolley) Storm, circa 1838

Oil on canvas, 33 × 27⁵⁄₁₆ inches (83.8 × 71 cm)
Inscribed on letter: [illegible]
69.7, Gift of Mrs. Waldo Hutchins, Jr.

Long a favorite among twentieth-century enthusiasts of folk art, Ammi Phillips was an itinerant limner who plied his trade in the towns near the New York–Massachusetts border and in Kent, Connecticut. This strikingly designed portrait demonstrates Phillips's remarkable ability to achieve a rigidly literal likeness through simple pictorial means. His sitter, Jeannette Woolley Storm (1814–1886), was the daughter of a Beekman, New York, farmer. She may have sat for the artist on the occasion of her marriage in 1839 to John Vincent Storm of Fishkill, New York.

In keeping with his manner of the late 1830s, Phillips rendered her form as a sharp-edged, decorative silhouette, transforming her elaborate coiffure into a composition of simple volumes that frame her face. The entire form of the dress, including the patternized pleats of the "demi-coeur" bodice so fashionable in the 1830s in America, appears wooden, owing to the heavy outlines and modeling in broad, schematic transitions. Jeannette Woolley Storm no doubt wore her finest for the portrait, including a rather naïvely described set of fancy jewelry. The chain around her neck, rendered in a rigid pattern of tiny gold links, holds a watch fob in the form of a hand, which echoes her own, heavily outlined, below. She holds a letter in her lap, and beneath her left hand rest two simply defined volumes of "History," a compositional device common to many of Phillips's portraits.

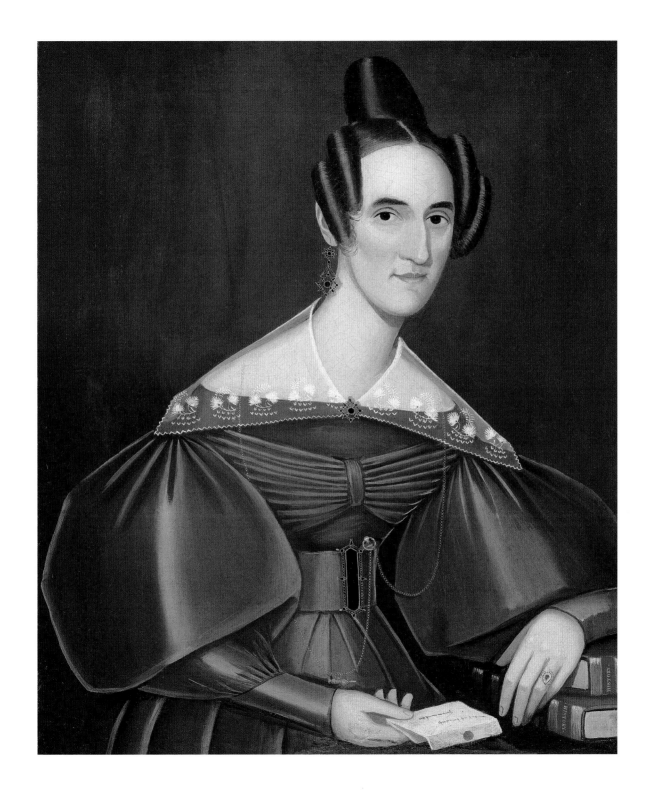

Emanuel Leutze

(May 24, 1816–July 18, 1868)

Columbus before the Queen, 1843

Oil on canvas, 38⁹⁄₁₆ × 50¹⁵⁄₁₆ inches (96.6 × 129.4 cm)
Signed lower right: "E. Leutze- 1843."
77.220, Dick S. Ramsay Fund and A. Augustus Healy Fund B

Emanuel Leutze painted *Columbus before the Queen* just two years after enrolling in the prestigious Royal Academy in Düsseldorf, where he was trained as a history painter and schooled in the use of art in the service of political expression. The latter impulse was inspired in part by Carl Friedrich Lessing, a mentor whose history paintings championed resistance to monarchy and the papacy. This is the third of Leutze's six Columbus subjects, which expressed the artist's American identity and his admiration for the man, viewed at the time as a fiery, anti-establishment hero. Leutze based these narratives on Washington Irving's *Life and Voyages of Christopher Columbus* (1828), which portrayed the Italian explorer and envoy of the Spanish crown as the heroic founder of the North American colonies.

Here Leutze's subject was a moment of tense confrontation between Columbus and his former champions, the king and queen of Spain, who had ordered Columbus's removal from their colony on Santo Domingo, Hispaniola (Haiti), in 1499, following a revolt against his authority. As portrayed by Leutze, Columbus stands erect and defiant before the remorseful monarchs and the Spanish court, with the opened manacles with which he had been shackled lying at his feet. Leutze rendered the subject with the precise draftsmanship, high color, and polished execution of the Düsseldorf manner, setting the elaborate figure composition within a richly decorated Moorish-inspired interior. This work and all of Leutze's Columbus subjects were eagerly embraced by his patriotic American audience.

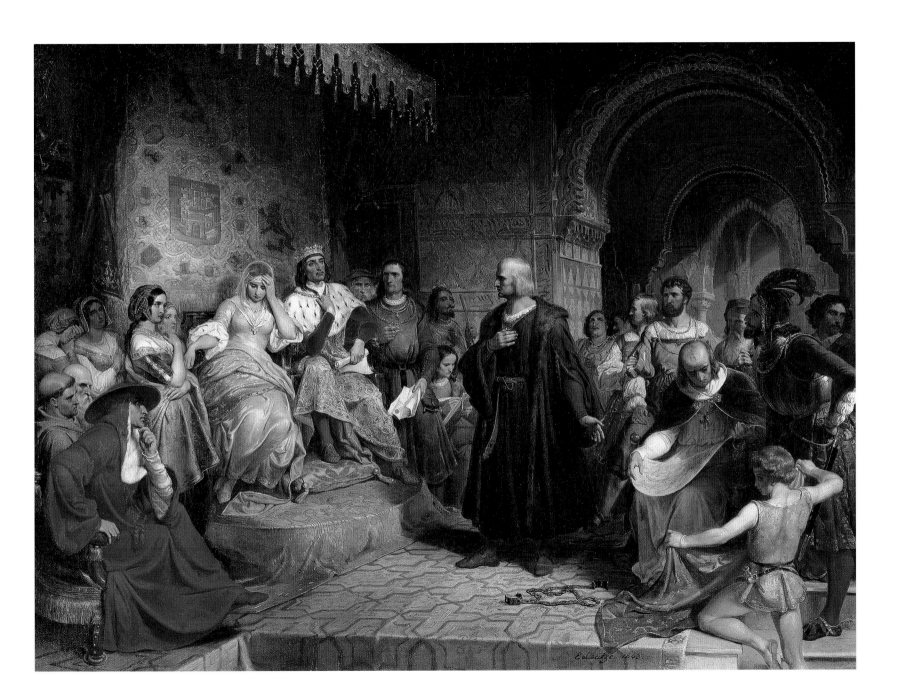

Thomas Cole

(February 1, 1801–February 11, 1848)

A Pic-Nic Party (formerly *The Pic-Nic*), 1846

Oil on canvas, 47⅞ × 54 inches (121.6 × 137.2 cm)
Signed lower center: "T Cole / 1846"
67.205.2, A. Augustus Healy Fund B

America's first great landscape painter, Thomas Cole earned his reputation with Romanticized views of the American Northeast and lofty allegorical subjects that challenged his American audience. In *A Pic-Nic Party*, Cole imagined American scenery in an inhabited but unspoiled state, achieving his finest American pastoral and one of his most successful figural compositions. He further invested the scene with elegiac meaning by employing the persona of his late friend Cornelius Ver Bryck as the bemused guitarist whose music, a traditional pastoral element and a familiar *vanitas* symbol in art, suggests the ephemerality of an ideal afternoon or of a human life.

Cole undertook this work on commission from the wealthy New York banker and philanthropist James Brown, who, like many collectors of the period, had a particular taste for distinctly legible figures set in a detailed landscape. Cole's choice of the picnic theme demonstrated his own belief that pastoral landscapes gently shaped by human use had an improving effect on human sentiment and behavior, instilling idealism and aesthetic awareness. He had previously explored these ideas only in his Italian and Arcadian scenes of artful, rustic life. Particularly in the wake of his second European sojourn, however, he was determined to see his native environment as a focus for ideal rather than utilitarian pursuits and as a source of spiritual and moral lessons. Cole crafted the setting into an accommodating one, modeling it on seventeenth-century classical landscapes in which gently receding planes are linked by a curve of water's edge. He paid particular attention to the informal dispersal of both the figures and the trappings of the picnic throughout the landscape, underscoring the natural setting as the source of physical and spiritual sustenance. He also signaled the group's surrender to the liberating and elevating forces of nature by showing proper American ladies relinquishing their conventional bonnets for circlets of wildflowers.

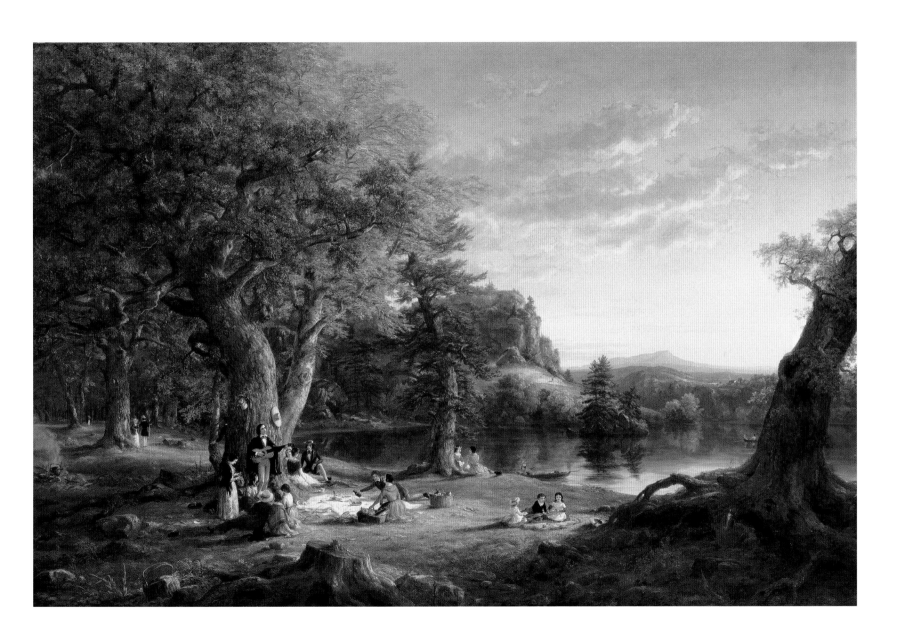

William Sidney Mount

(November 26, 1807–November 18, 1868)

Caught Napping (formerly *Boys Caught Napping in a Field*), 1848

Oil on canvas, 29¹⁄₁₆ × 36⅛ inches (73.8 × 91.7 cm)
Signed lower left: "Wᵐ. S. MONNT. [*sic*] / 1848."
39.608, Dick S. Ramsay Fund

From 1830 William Sidney Mount painted scenes of Long Island farm life that advanced the taste for sentimental and humorous genre subjects among an audience of rising upper-middle-class New Yorkers. Mount painted *Caught Napping* for the Long Island–born New Yorker George Washington Strong, who wished to commemorate a reminiscence from his own country childhood in Mount's native Setauket (the boys in the scene represent his brothers, and the farmer his father, Selah B. Strong). It was the second such work Mount painted for Strong, who had already commissioned the artist's *Eel Spearing at Setauket,* 1845 (New York State Historical Association, Cooperstown). More than purely personal nostalgic gestures, however, the Strong commissions were part of a current vogue among urbanites for scenes that aggrandized their rise in social and economic status by evoking their humble origins.

Mount began the landscape backdrop for *Caught Napping* outdoors in order to achieve a lively plein-air colorism, apparent in the distinctly bright tonalities that some of his critics found to be extreme. The painting nevertheless was among the most noted canvases at the National Academy of Design's 1848 annual exhibition. In keeping with a current mode of response to such works, critics elaborated on the narrative of the idle farm boys, referencing the myriad anecdotal details that Mount included in the scene. The theme of rural boyhood would become one of the most popular subjects for American genre painters in the decades after the Civil War, a time when urban centers increasingly drew people away from their native rural environments.

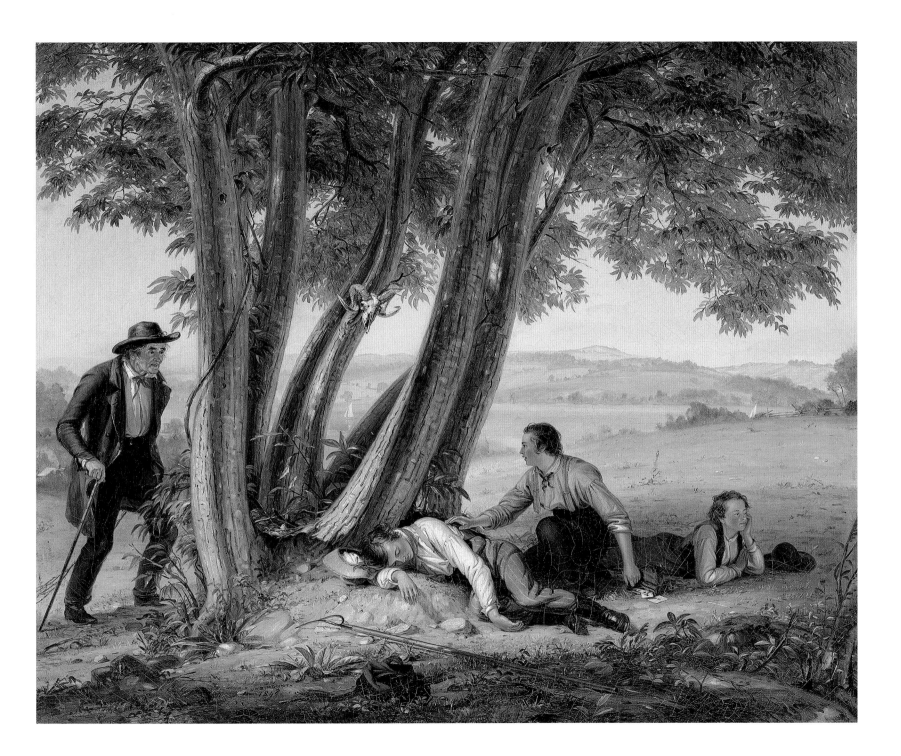

George Caleb Bingham

(March 20, 1811–July 7, 1879)

Shooting for the Beef, 1850

Oil on canvas, 33⅜ × 49 inches (84.8 × 124.5 cm)
Signed lower left: "G. C. Bingham / 1850."
40.342, Dick S. Ramsay Fund

This distinctive rustic narrative is the work of George Caleb Bingham, a painter and politician who established his reputation with innovative genre subjects that offered a surprisingly candid view of frontier life in his native Missouri. After focusing on Missouri boatmen in the late 1840s, Bingham turned to the rough but amiable types who inhabited the river's shores. In this lighthearted composition he portrayed a group of men and dogs gathered in front of a primitive, wooden "Post Office–Grocery" for a shooting contest; their target is a nail on the board leaning against the dead tree at the right, and the prize is the glum-looking steer at the far left.

In his usual manner, Bingham assembled a combination of stock figure types, which were based on his large repertoire of preparatory drawings. He carefully redrew the figures on the canvas and completed the painting with his customary precise touch and generally bright color. *Shooting for the Beef* debuted in a Saint Louis emporium to lively acclaim. The canvas had its New York debut some months later at the American Art-Union, an organization committed to the promotion of art that offered distinctly national subjects and anecdotal accessibility. If Bingham's New York critics were more critical of his talents than the artist's local audience, they nonetheless appreciated his expression of one distinct branch of the national character.

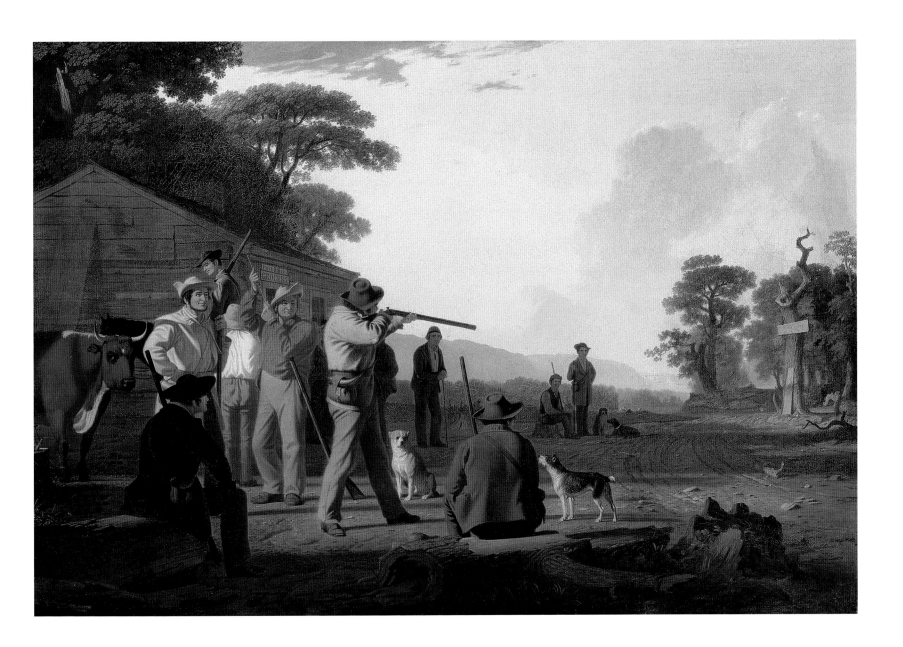

Asher B. Durand

(August 21, 1796–September 17, 1886)

The First Harvest in the Wilderness, 1855

Oil on canvas, 31⅝ × 48 1/16 inches (80.3 × 122 cm)
Signed lower center: "A B Durand, pt. / 1855"
Inscribed on boulder, lower right: "Graham"
97.12, Transferred from the Brooklyn Institute of Arts and Sciences to the Brooklyn Museum

Perhaps the most enduring practitioner of the Hudson River School aesthetic, Asher B. Durand undertook this remarkable landscape allegory in response to a landmark commission from The Brooklyn Institute, the forerunner of today's Brooklyn Museum. The commission was the first initiated in fulfillment of a bequest by Augustus Graham, a leading Brooklyn philanthropist and former Brooklyn Institute president, to fund works by living American artists for a proposed, unparalleled permanent gallery open to the general public. The selection of America's leading landscape painter as the inaugural recipient signaled the Institute's great ambition for the Graham painting bequest.

Durand, whose outlook and art were optimistic as well as spiritual, responded with a landscape inscribed with the overarching notion of national progress and the more specific idea of the cultural progress engendered by Graham's progressive ideals and prodigious generosity. Building on the landscape allegories of cultural progress coined by his mentor, Thomas Cole, Durand here cast the American wilderness as the site of civilization's divinely predestined advance; the isolated pioneer cultivating his immediate surroundings contributes to the slow but certain transformation of the country into a more advanced and powerful nation. Within this narrative Durand inserted an allusion to Graham's contribution to American cultural life through the inscription of the funder's name on the massive boulder in the lower right foreground. In reporting Durand's fulfillment of the commission, *The Crayon* reported patriotically on July 4, 1855, "The field of Art is, in the country, but just emerging into the reality of a clearing, upon which the sun of encouragement *does* shine, if it gleams from clouds and is surrounded by shadows. . . . Mr. Graham may be considered the pioneer in the wilderness, and all honor be to his memory for being the first to make a clearing."[1]

1. "Domestic Art Gossip," *The Crayon* 2, no. 1 (July 4, 1855): 9.

Lilly Martin Spencer

(November 26, 1822–May 22, 1902)

Kiss Me and You'll Kiss the 'Lasses, 1856

Oil on canvas, 29¹⁵⁄₁₆ × 24¹⁵⁄₁₆ inches (76 × 63.3 cm)
Signed lower right: "Lilly M. Spencer / 1856"
70.26, A. Augustus Healy Fund

An accomplished artist and the head of a large family, Lilly Martin Spencer won popular acclaim for her boldly humorous portrayals of middle-class domestic life. Spencer painted *Kiss Me and You'll Kiss the 'Lasses* on commission from the Cosmopolitan Art Association, a short-lived organization whose interests included promoting art by women to a female audience. Very likely with that audience in mind, Spencer portrayed a jaunty young woman interrupting her culinary pursuits to challenge the unseen interloper presuming to kiss her. Easily read as a self-portrait of the artist, this figure directly confronting the viewer embodies a puzzling mix of the proper domestic woman and an antithetical, playfully autonomous persona.

Spencer employed such assertive types not only to reach out to women isolated in domestic settings, but to raise her own voice in the male-dominated New York art world to which her access was severely limited. Critics alternately found such candid subjects distinctly feminine or unsuitably coarse for an artist of the "gentler sex." These images nevertheless constitute Spencer's original contribution to the repertoire of characterizations in American genre art. Beyond her engaging figures, her work offered the aesthetic appeal of deftly painted still-life details—a feature that her audience associated with popular nineteenth-century German and Dutch styles. Here the foreground vignette virtually overflows with a sumptuously colorful display of late-summer fruits that speak of the season in which Spencer began the painting.

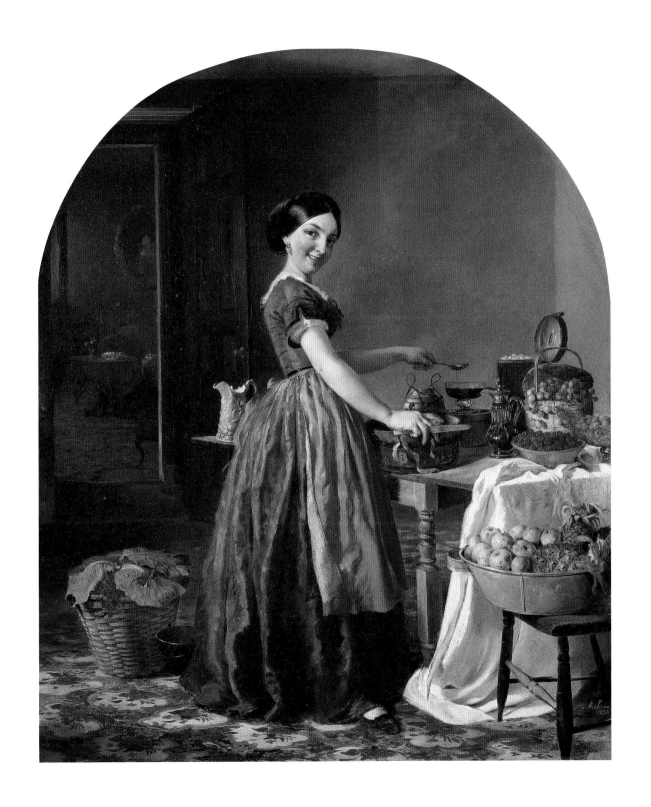

Fitz Hugh Lane

(December 19, 1804–August 14, 1865)

Off Mount Desert Island, 1856

Oil on canvas, 24 × 35¹⁄₁₆ inches (61 × 91.8 cm)
Signed lower left: "F H Lane 1856"
47.114, Museum Collection Fund

The rugged landscape of Maine's Mount Desert Island first attracted American artists in the 1830s and by midcentury was the painting ground for such notables as Frederic Edwin Church and John Frederick Kensett. For the Boston-area marine painter Fitz Hugh Lane, the visual impact of the island's secluded shoreline and natural harbors inspired a late-career style distinctive for its formal austerity and quietist mood. Lane made regular visits to Mount Desert throughout the 1850s, boarding in nearby Castine and sailing to the island on a chartered sloop. While his traveling companions explored the inland reaches, the artist usually made his pencil sketches on deck, owing in part to physical disabilities that prevented him from easily covering rugged terrain on foot.

Off Mount Desert Island marks Lane's break with his earliest Mount Desert subjects, in which he had focused on the lively coastal activity associated with the local timber trade. Here and in his subsequent Mount Desert canvases, he exchanged the details of anecdotal narrative for distilled compositions and a highly emotive use of light and color. Lane set this scene at the mouth of a natural harbor, with a characteristic string of rock peaks visible in the distance. He offered no signs of habitation or inviting inland vistas, perhaps to conjure the experience of the place in a distant past. The emphatically limited narrative is contained in the still, shadowy form of a ship at the right, a small, manned dory heading for shore, and the nearly phantomlike sailing ship at the far left. Lane devoted considerable effort to rendering the expressive twilight sky and the effects of an intense, raking lavender-pink light, brushed onto the westward face of the pale gray rock cliffs. He reverted to his penchant for fine detail only in the description of the ship's rigging, which he executed with a sure, free hand.

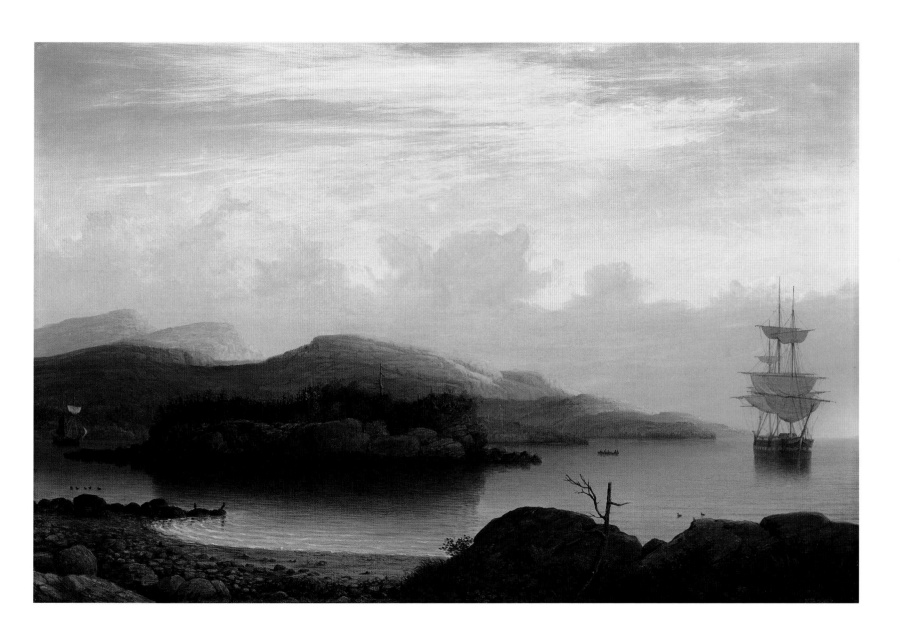

John William Casilear

(June 25, 1811–August 17, 1893)

View on Lake George, 1857

Oil on canvas, 37⅝ × 60 inches (95.5 × 152.4 cm)
Signed lower left: "J.W.C. / 57."
76.56, Gift of The Roebling Society and Dick S. Ramsay Fund

Painted in the year that John William Casilear ended his successful career as an engraver, this panoramic view of Lake George is probably the largest and most ambitious work of his career, and one whose scale and careful execution embodied the high expectations with which he turned to his second profession. Casilear probably traveled to Lake George for the first time in 1855, joining his good friend and colleague John Frederick Kensett, who had already begun to frequent the area as it became an increasingly popular touristic destination. When he undertook this canvas in the years immediately following, Casilear chose a dramatically elevated vantage point at the southern or "head end" of the lake, looking north toward the eastern shore and, at the very center of the canvas, the termination of the peninsula formed by First Peak of the Tongue Mountain Range. To the right of the Narrows rises the smaller, pointed peak of Shelving Rock and the forms of Little Buck and Big Buck mountains.

The breadth, depth, and comparatively unbounded character of this view link it to other major achievements in midcentury American landscape painting wherein Casilear's colleagues eschewed the heavy and expressive framing devices typical of Thomas Cole's Romantic style to present a more natural or "truthful" view. Casilear went a step further by cropping the forms of the foreground, water, and mountains at the right side of the canvas, thus allowing the viewer a certain freedom of entrance into the scene and emphasizing the continuation of the landscape beyond the confines of the frame. The legacy of the artist's long tenure as an engraver is evident throughout this large canvas in the carefully controlled and detailed execution.

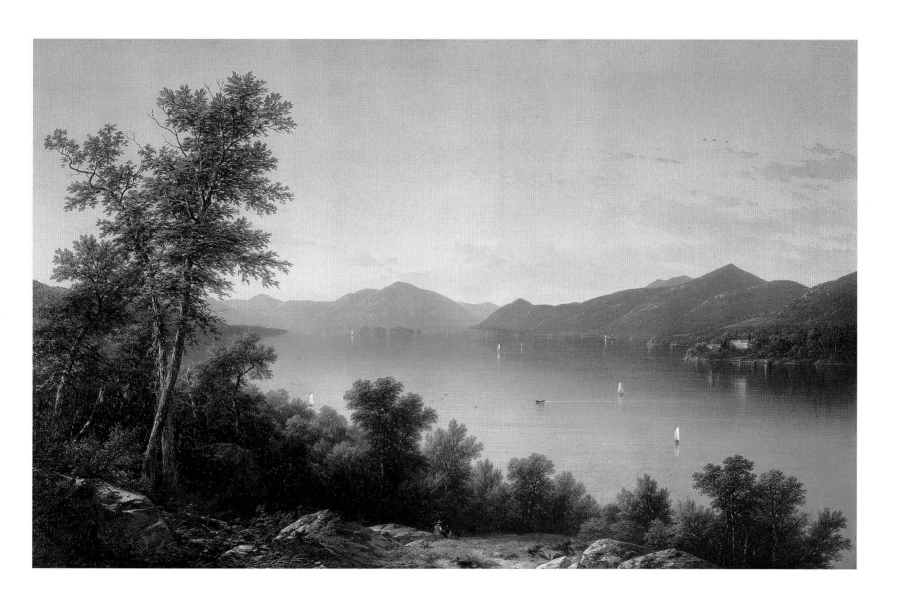

Robert Walter Weir

(June 18, 1803–May 1, 1889)

Embarkation of the Pilgrims, 1857

Oil on canvas, 48⅛ × 72¼ inches (122.2 × 183.5 cm)
Signed lower left: "Rob.ᵗ W. Weir. / 1857."
75.188, A. Augustus Healy Fund and Healy Purchase Fund B

A leading proponent of historical and religious art in antebellum America, Robert Walter Weir produced this reduced version of his grand Capitol Rotunda mural *Embarkation of the Pilgrims*, 1843, in a climate of renewed sectional pride and competition. Charged with deriving a mural subject from colonial history, Weir had turned to Nathaniel Morton's *New England's Memoriall* (1669; reprinted 1826) for the narrative of the group of English Puritans who in 1620, after ten years of asylum in Leiden, set out aboard the *Speedwell* to seek a new American homeland. The subject projected Weir's own religious faith and asserted the primacy of the New England colonies in the establishment of Protestantism in America. He selected the moment of high drama in Morton's text, when the pilgrims parted with their brethren who were to remain in the Dutch city despite what they perceived to be its licentious and unhealthy environment.

In composing the scene, Weir borrowed liberally from Rembrandt's famous "Hundred Guilder Print," or *Christ with the Sick around Him, Receiving the Children*, circa 1649, in which a dramatic pyramidal composition of seated and kneeling figures is set within an enclosed space and lit from the left by a strong raking light. Here the kneeling Elder William Brewster assumes a Christ-like role among his flock, who were individually identified in a pamphlet that accompanied the debut of the 1843 mural and included the soldier Miles Standish and his wife. Adhering to the methods of French nineteenth-century academic history painting, Weir fastidiously inserted "documentary" details of costume and architecture to lend the painting greater accuracy. He probably undertook this reduced version early in 1857 for the production of an engraving that was offered for sale to an eager audience. Although Weir closely replicated the precisely drawn and detailed figures of the mural, he modified the palette to a warmer tone with some richly colorful passages, very likely in response to certain critiques of the original. He exhibited this work in a number of highly visible venues, including the 1876 Philadelphia Centennial Exhibition, a setting in which the subject was particularly resonant.

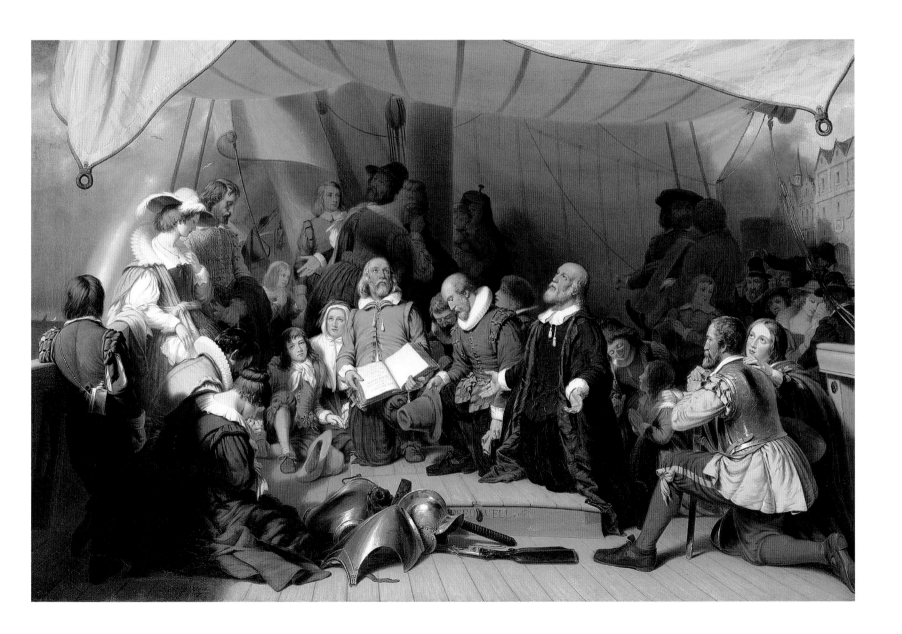

Daniel Huntington

(October 14, 1816–April 18, 1906)

The Sketcher: A Portrait of Mlle Rosina, a Jewess, 1858

Oil on canvas, 39 × 31³⁄₁₆ inches (99.1 × 79.2 cm)
Signed lower right: "D. Huntington / Paris 1858"
97.33, Transferred from the Brooklyn Institute of Arts and Sciences to the Brooklyn Museum

An influential mid-nineteenth-century American portrait and figure painter, Daniel Huntington was one of a relatively limited number of American artists who devoted their energies to idealized figure subjects rather than to anecdotal genre scenes. *The Sketcher*, one of the first paintings to enter the collection of The Brooklyn Institute (the precursor of the Brooklyn Museum), is typical of the ideal figures with which the artist first experimented during his visits to Italy in the 1840s, in response to the highly refined art of the Renaissance. Huntington often reprised this ideal type, employing allegorical or literary references in order to individualize the figures. He undertook this composition in Paris during his longest sojourn abroad, when he may have come in contact with representations of the Romantic theme of the virtuous Jewess Rebecca from Sir Walter Scott's *Ivanhoe*.

Unlike the more exotic interpretations of the subject, however, including high-keyed orientalist renditions by the French painter Eugène Delacroix, Huntington's composition employs a sweetly beautified Italianate figure with a minimum of additional narrative content. In describing the graceful girl engaged in drawing in a tranquil plein-air setting, he effectively created a personification of artistic creativity. He included only one relatively orientalist touch, in the form of the palm tree that the sketcher has outlined on a page of her sketchbook. Perhaps owing to its reference to aesthetic practice, Huntington selected this work to fulfill his prestigious commission from the fledgling Brooklyn Institute as it inaugurated its new American painting collection.

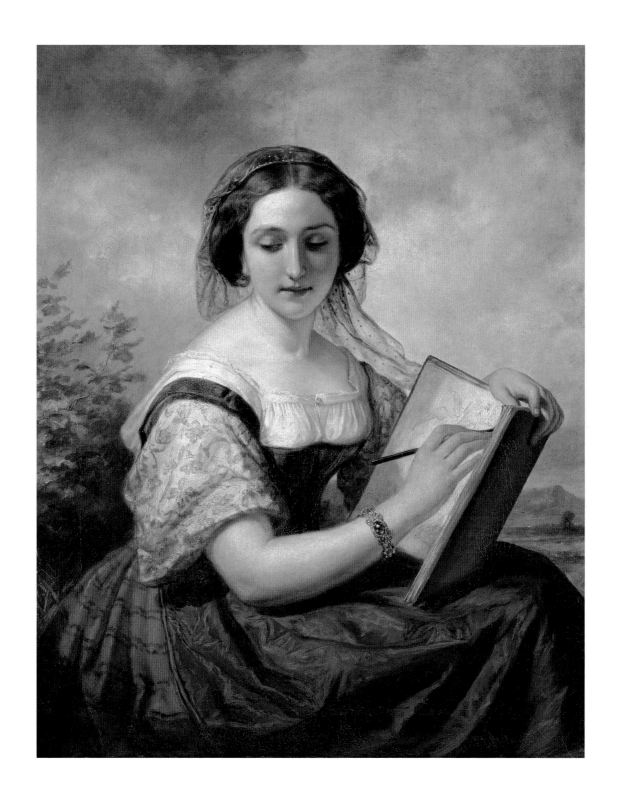

Albert Fitch Bellows

(November 29, 1829–November 24, 1883)

Life's Day, or Three Times Across the River: Noon (The Wedding Party), 1861

Oil on canvas, 29 × 47 inches (73.7 × 119.4 cm)
Signed lower left: "A.F. Bellows. 1861"
2000.8, Dick S. Ramsay Fund

Although Albert Fitch Bellows was known primarily for depictions of the rural New England landscape, his most memorable works include a three-painting ensemble entitled Life's Day, or Three Times Across the River, in which this canvas, Noon (The Wedding Party), figured as the central image. In concert with the flanking paintings of Morning and Evening (Private Collection), it constitutes a cycle-of-life narrative cast in the intimate, domestic terms of an American woman's progression from the cradle to the grave. Bellows's choice of this conceit rather than a grander allegorical cycle-of-life narrative along the lines of Thomas Cole's The Course of Empire or The Voyage of Life coincided with a shift in the American visual arts away from the history painting mode to that of genre. More particularly it partook of the mid-century "cult of domesticity," through which womanhood

was elevated to an unparalleled cultural status as the locus of moral authority.

Bellows placed all three scenes in the same picturesque landscape setting along the Farmington River in Windsor, Connecticut, varying the season according to the progressive life stages of the central figure: spring and baptism; summer and marriage; and winter and death. His work on the series was the subject of lively local interest, owing in part to the participation of a number of Windsor residents as models for the various figures. The noted American actor Edwin Forrest purchased the suite of paintings soon after their completion; his choice of so emphatic a celebration of the traditional passages in a woman's life is all the more interesting in light of his own highly publicized marital strife.

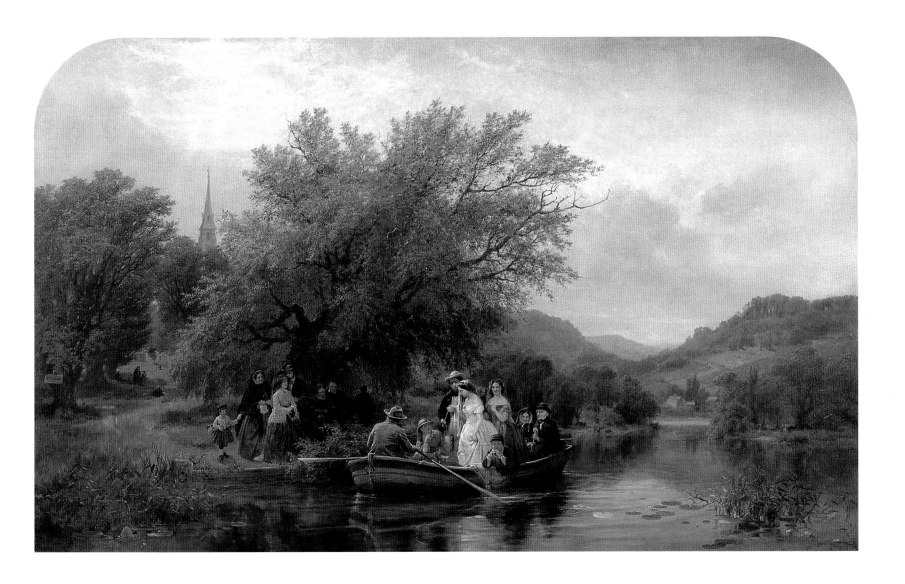

New Maturity

American Painting in the Civil War Era

THE IMPRINT OF THE WAR EXPERIENCE ON AMERICAN PAINTING was definitive but indirect. Although few American artists attempted to record the innumerable tragic or heroic events brought by the protracted, violent cataclysm of the war—Eastman Johnson's *A Ride for Liberty—The Fugitive Slaves* is a rare exception—paintings of the war years and the decade that followed were often marked by a new degree of emotive nuance and mood of sobriety and interiority. Landscapes frequently were inscribed with portentous symbols of peace and prosperity, and narrative treatments of domestic or regional traditions attained fresh meaning owing to the newly perceived fragility of established ways of life. Many works of the era, across genres, demonstrated an inclination toward tenebrism, derived in part from contemporaneous European styles and broadly associated with the somber postwar American mood.

Artistic expression was, however, far from monolithic. Among the exceptions to the new, introspective restraint of the Civil War era were forcefully optimistic expressions of the expansionist philosophy of Manifest Destiny, best embodied in the monumental landscape art of

Albert Bierstadt. These pictorial statements nevertheless were outnumbered by paintings of domesticated northeastern landscapes and other, thoughtfully circumscribed and distilled views based on intimate observation and quietist moods.

A number of artists made assertive attempts to move American painting forward with fresh subjects and new techniques. During the 1870s the first wave of a new generation to seek training in progressive European settings returned with updated styles, including the Munich-derived, painterly Realism practiced by Frank Duveneck. Winslow Homer and Albert Pinkham Ryder, while familiar with current European trends in painting, advanced American art with more personal and idiosyncratic experiments in pictorial design.

The Civil War era was the last moment during which the majority of American artists were trained in the United States and deliberately sought their subjects at home. Newly free to travel in the postwar years and eager to infuse their artistic practice with sophisticated methods and more daring subject matter, they would willingly exchange their provincial identities for determinedly cosmopolitan ones.

Detail, ill. p. 85

George Inness

(May 1, 1825–August 3, 1894)

On the Delaware River, 1861–63

Oil on canvas, 28¼ × 48¹⁄₁₆ inches (71.8 × 122 cm)
13.75, Special Subscription Funds

This vibrantly colorful scene of the Delaware Water Gap is something of a transitional work in the oeuvre of George Inness, who began his career as a student of the Hudson River School aesthetic but evolved a highly expressive manner that came to dominate late nineteenth-century American landscape art. Inness employed an expansive Hudson River School–style format in this view of the Delaware River framed by the Kittatinny Ridge in the Appalachian Mountains. He deliberately moved beyond that mode, however, in his use of a broader touch and bright tonalities, techniques with which he had begun to experiment by the early 1860s under the influence of French plein-air painting of the period.

Like many of his American peers, Inness also had begun to demonstrate a preference for more settled, bucolic settings, and to that end he here inserted the narrative elements of the river rafts and train, and the cattle and homestead. For Inness, this inclination stemmed from his increasing idealization of landscapes on which human labor had made a mark. The optimistic vision of *On the Delaware River* informed a number of the artist's most important canvases of the early Civil War period, in which clearing skies and human industry were read as portents of peace, and flourishing landscapes as a promise of prosperity.

The liveliness of this image, however, derives primarily from its dynamic design, including the dramatically elevated vantage point and the animated description of the cloud-filled sky and strong, shifting light. Much of the painting's brilliance may be attributed to Inness's application of the paint directly on a white ground.

Eastman Johnson

(July 29, 1824–April 5, 1906)

A Ride for Liberty—The Fugitive Slaves, circa 1862

Oil on board, 21¹⁵/₁₆ × 26⅛ inches (55.8 × 66.4 cm)
Signed lower left: "E.J."
40.59A, Gift of Gwendolyn O. L. Conkling

A leading figure painter of the Civil War era, Eastman Johnson was unusual in his pursuit of challenging subjects that addressed the pressing social and political issues of the day. From the time of his sensational New York debut in 1859 with *Negro Life at the South* (The New-York Historical Society), Johnson demonstrated a progressive interest in the sympathetic representation of enslaved African Americans. Although throughout the war years his political statements were embedded primarily in representations of rural New England life, in 1862 he traveled to Manassas, Virginia, presumably under the aegis of General George McClellan and the Army of the Potomac, to undertake more directly topical themes. The expedition yielded *A Ride for Liberty—The Fugitive Slaves*, as indicated by Johnson's inscription on another version (Virginia Museum of Fine Arts, Richmond): "A veritable incident / in the civil war seen by / myself at Centerville / on this morning of / McClellan's advance towards Manassas March 2, 1862 / Eastman Johnson."

In this exceptional work, distinguished by its direct representation of a war-related event, Johnson transformed his eyewitness experience into an unparalleled image of enslaved blacks independently striving for freedom. Altering the composition as he worked on the canvas, he intensified the dynamism of the scene by unifying the primary players—the charging horse and its four riders—within a strong, continuous silhouette dominated by the tensed and straining horse. Johnson framed the group against the nebulous, early-morning setting of a battlefield, whose forms are only vaguely suggestive of the actual site's rolling terrain and barricades. The politically loaded nature of this subject may underlie the fact that Johnson appears never to have exhibited or sold any of his three variations on the theme. His subsequent African American subjects, cast in the vein of his rustic country narratives, were only subtly political.

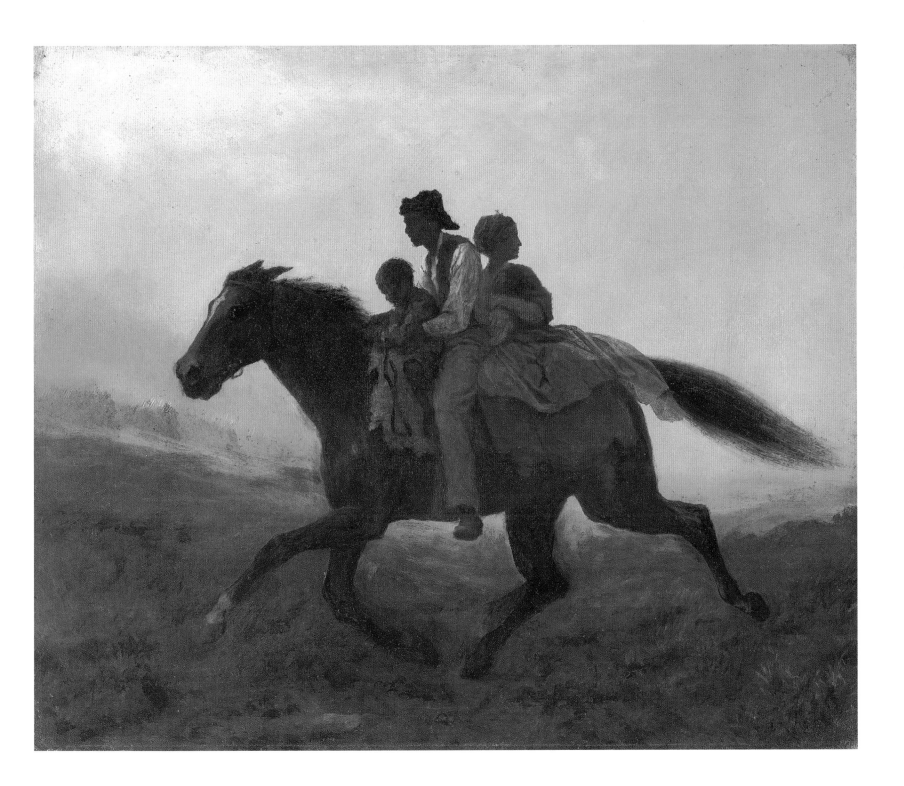

Albert Bierstadt

(January 7, 1830–February 18, 1902)

A Storm in the Rocky Mountains, Mt. Rosalie, 1866

Oil on canvas, 83 × 142¼ inches (210.8 × 361.3 cm)
Signed lower right: "ABierstadt / N.Y. 1866"
76.79, Dick S. Ramsay Fund, Healy Purchase Fund B, Frank L. Babbott Fund, A. Augustus Healy Fund, Ella C. Woodward Memorial Fund, Carll H. de Silver Fund, Charles Stewart Smith Memorial Fund, Caroline A. L. Pratt Fund, Frederick Loeser Fund, Augustus Graham School of Design Fund, Museum Collection Fund, Special Subscription, and the John B. Woodward Memorial Fund; Purchased with funds given by Daniel M. Kelly and Charles Simon; Bequest of Mrs. William T. Brewster, Gift of Mrs. W. Woodward Phelps in memory of her mother and father, Ella M. and John C. Southwick, Gift of Seymour Barnard, Bequest of Laura L. Barnes, Gift of J. A. H. Bell, and Bequest of Mark Finley, by exchange

One of the most prominent landscape painters of the nineteenth century, Albert Bierstadt established his reputation with grand-scale and dramatically conceived "Great Pictures" of the American West that embodied the national agenda of expansionism known as Manifest Destiny. *A Storm in the Rocky Mountains, Mt. Rosalie*, an eighty-four-square-foot canvas that stands as a pivotal work in Bierstadt's very public career, was the most important painting to result from the artist's second western expedition, in 1863.

To promote public anticipation of the painting, Bierstadt had engaged the writer Fitz Hugh Ludlow to accompany him on the expedition and chronicle their westward trek for a number of newspapers and periodicals. After traveling from New York to Denver, Bierstadt went on to the vicinity of what is today Mount Evans and the Chicago Lakes. There, over the course of several strenuous days, he recorded in pencil and oil studies the sublime aspects of the towering peaks and expansive valley, and of the turbulent weather conditions. Bierstadt executed the canvas after his return to his New York studio, creating a highly expressive, wide-angle composition animated by the elements of rushing water, extreme contrasts of cast light and shadow, and miniaturized narrative details including a band of Indians in pursuit of their horses. He diverted the viewer's attention with a repertoire of geologic phenomena in the background and myriad botanically correct details in the foreground.

Bierstadt debuted the painting at the Somerville & Miner Gallery before sending it on a yearlong national tour. The large audiences that thronged to view this work after the close of the Civil War regarded its Edenic characterization of the heart of the continent as emblematic of redemption and promise. Rapt viewers found additional drama in the fact that its nominal subject—the central peak, Mount Rosalie (now Mount Evans)—was christened for Ludlow's wife, who by late 1866 was divorced and remarried to Bierstadt. The canvas nevertheless met with mixed critical reviews; while defenders extolled its scale, accuracy, and "artistic unity," detractors berated its extreme artifice and hyperbolic expression. The

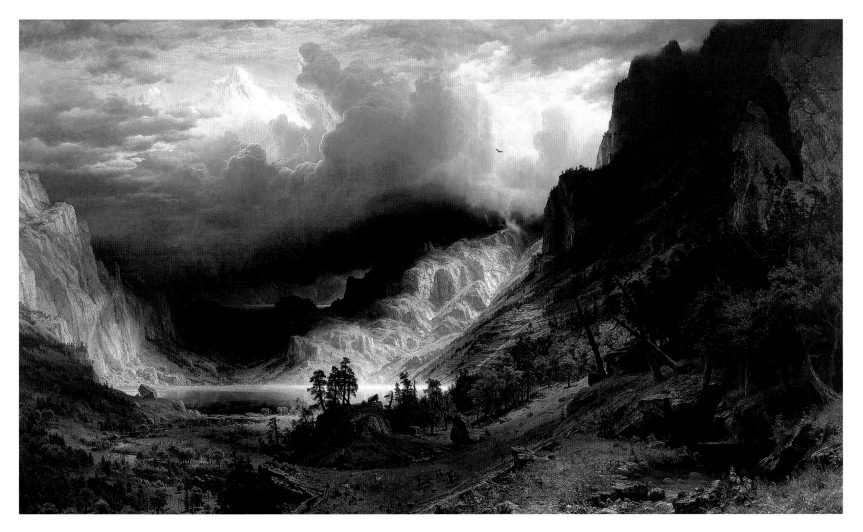

lively critical dialogue signaled changes in American taste, away from the descriptive Realism based on earlier English and German landscape models.

A Storm in the Rocky Mountains, Mt. Rosalie was acquired for a record price by Thomas William Kennard, an English civil engineer who had supervised the building of the Atlantic and Great Western Railway in the United States. After its American tour, the painting was exhibited in London and Paris, and reproduced in a long-popular chromolithograph. Sometime after Kennard's death in 1896, the canvas passed to a London frame and picture dealer, James Bourlet & Sons, in whose inventory it remained, largely forgotten, until its rediscovery in 1974.

Louis Rémy Mignot

(February 3, 1831–September 22, 1870)

Niagara, 1866

Oil on canvas, 49⁷⁄₁₆ × 91½ inches (123.8 × 232.4 cm)
Signed lower right on rock: "M. / 70"
1993.118, Gift of Arthur S. Fairchild

This expansive yet poetic view of the American icon Niagara Falls is considered the finest work by Louis Rémy Mignot, a southern-born painter who expatriated to Britain after the outbreak of the Civil War. Known primarily for atmospheric South American landscapes based on his travels with the painter Frederic Edwin Church, Mignot very likely undertook this canvas in response to Church's own *Niagara*, 1857 (Corcoran Gallery of Art, Washington, D.C.), a highly detailed treatment of the subject that had secured the latter's reputation at home and in London.

Niagara was among the most distinctly American of all motifs, conjuring the sense of the natural might that underlay the notion of predestined American promise. Perhaps already determined to assert his enduring American identity through this subject, and additionally to surpass the achievement of his friend and rival Church, Mignot quite deliberately completed sketches at the site just before he moved to London in 1862. In this highly ambitious canvas, Mignot took his view from the opposite side of the great Horseshoe Falls, facing the Canadian shore, from a vantage point atop Terrapin Tower on Goat Island. Although he adopted a suspended viewpoint as Church had, he advanced that innovation by omitting all traces of earthbound rocky outcroppings. Mignot's falls are thus more immediate and more absorbing, as well as dramatically broader and more expressive in execution. He evocatively described the rushing torrents in the foreground, the opposing currents churning at the left, and the mist rising at the right, as if seen through a heavy atmosphere tinted with the lavender light of sunset.

Mignot debuted *Niagara* in London in 1866 to great acclaim; the painting made its American debut after his death, when it was included in the display of American art at the 1893 World's Columbian Exposition in Chicago.

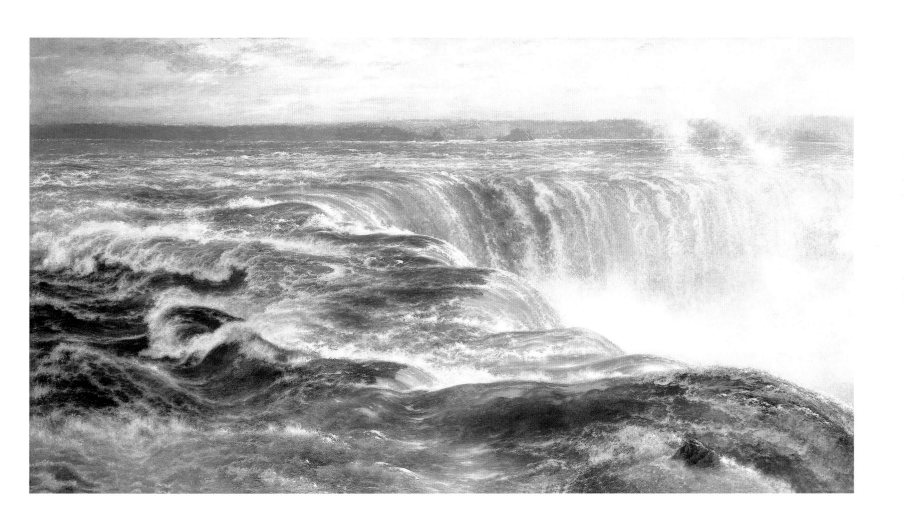

Martin Johnson Heade

(August 11, 1819–September 4, 1904)

Summer Showers, circa 1865–70

Oil on canvas, 13⅛ × 26¼ inches (33.4 × 66.6 cm)
Signed lower left: "M J Heade"
47.8, Dick S. Ramsay Fund

From the time that the peripatetic, mid-nineteenth-century painter Martin Johnson Heade seriously undertook landscape subjects in the late 1850s, he gravitated to the lowland, coastal salt marshes of the American Northeast, where salt hay and grass were harvested from June to October. Heade found in the subdued terrain and shifting atmosphere of these settings the forms best suited to his own aesthetic interests. In a number of particularly successful renditions of the theme from the late 1860s, he pushed his compositions toward an immediacy and informality uncommon in paintings by his more prominent Hudson River School colleagues.

Within this bluntly cropped view, which offers no traditional dramatic emphasis, he focused on the transcription of evanescent effects of light and weather. The key compositional element is the effectively realistic band of clouds that casts the foreground into palpably damp shadow. Framing the brilliant robin's-egg blue sky and sunny vista at the picture's center, the cloud band also puns on the margin of shadow cast onto pictures by mid-nineteenth-century frames. Despite his characteristic precise touch, Heade achieved an evocative subtlety in his description of the forms. This nuanced delicacy is particularly apparent in his delineation of the delicate wisps of mist extending downward from the hovering cloud.

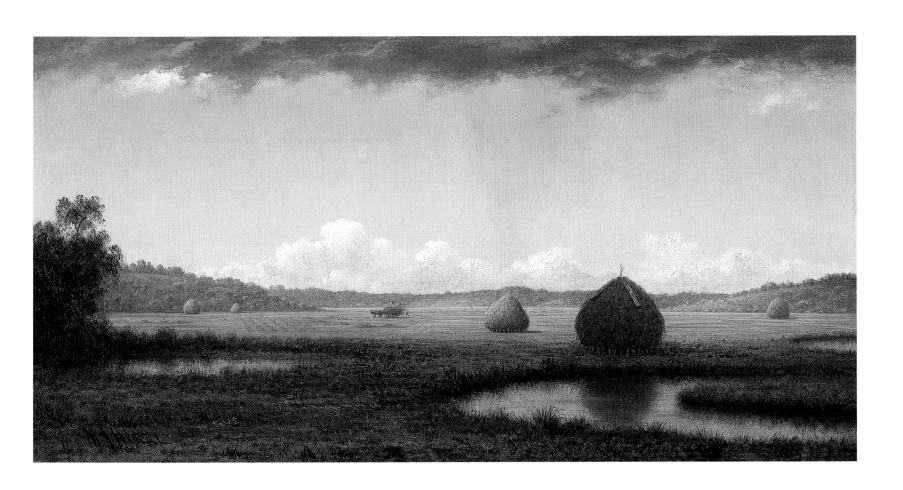

John Frederick Kensett

(March 22, 1816–December 14, 1872)

Lake George, 1870

Oil on canvas, 14 × 24⅛ inches (35.6 × 61.2 cm)
Signed lower right (first two initials in monogram): "JF.K. '70."
33.219, Gift of Mrs. W. W. Phelps in memory of her mother and father, Ella M. and John C. Southwick

One of the finest painters at work in mid-nineteenth-century America, John F. Kensett formulated a landscape mode distinguished by eloquently simplified compositions and evocative description of texture. In nearly all of his Lake George subjects, however, Kensett resisted the degree of compositional reduction that peaked in his late coastal subjects. In this intimate but exceedingly vibrant example, he offered an animated description of the varied shoreline and an effective suggestion of shifting atmosphere and changing light in the lakeside landscape. Among the liveliest elements in the image are the windblown birch branches set in raking light against a gray-blue sky, the gust-driven bits of low clouds, and the ruffled surface of the chilly, dull-toned water.

Kensett employed his characteristic, highly controlled brushiness to create subtle textures that suggest detail. Here he also achieved an exceedingly delicate use of rich autumnal color. A critic of the period who theorized that painters found in autumn the sentiments characteristic of their own natures described Kensett's autumn palette as one of "subdued richness and quiet and tender beauty of color." The writer continued: "[T]his is not that pomp of color . . . but a russet richness, just removed from soberness. . . . Here is no flaming crimson and gold, but browns and grays and delicate cinnamon hues."[1]

1. "Art—Kensett's Lake George," *The Round Table* 1, no. 14 (March 19, 1864): 216.

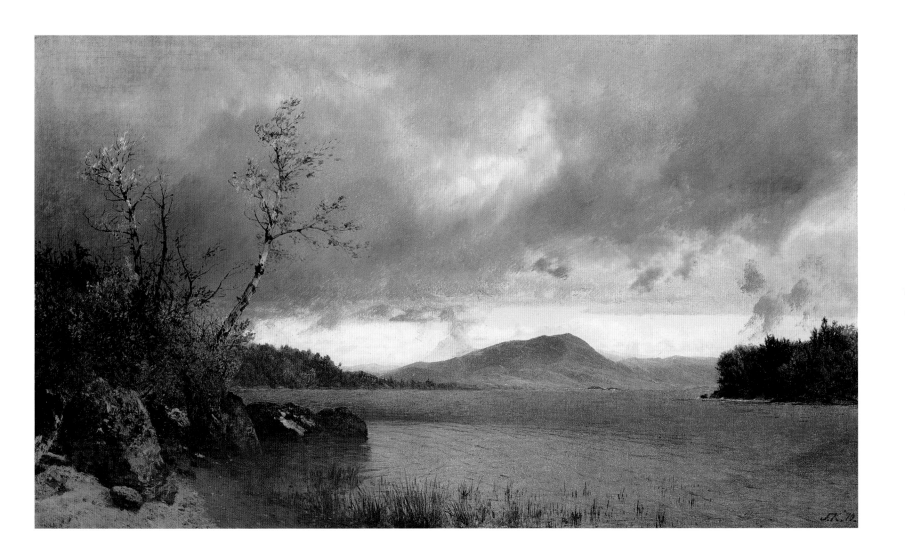

Frederic Edwin Church

(May 4, 1826–April 7, 1900)

Tropical Scenery, 1873

Oil on canvas, 38⁵/₁₆ × 59¹⁵/₁₆ inches (99.8 × 152.3 cm)
Signed lower center: "F. E. CHURCH / –73"
63.150, Dick S. Ramsay Fund

From the mid-1850s Frederic Edwin Church's reputation was based on numerous dramatic canvases that revealed the natural wonders of the South American Andes to engrossed American audiences. Church shared with many of his contemporaries an active interest in South America that was inspired in part by scientific theories, particularly Alexander von Humboldt's writings, which likened the region to the earth at the time of its origins. Responding to Humboldt's advocacy of landscape painting as an ideal combination of scientific observation and human feeling, Church had toured through the remote reaches of Colombia and into the upper regions of the Ecuadorian Andes in 1853 and 1857.

The vision of South America as a terra incognita and primordial paradise had diminished by 1873, when Church undertook this work on commission for Robert Hoe, a wealthy printing-press manufacturer, renowned bibliophile, and a founder of the Metropolitan Museum of Art. The artist's subsequent travels to Europe and the Near East had also intervened, removing him a step further from his South American experiences and placing him in contact with thoroughly settled landscapes.

In *Tropical Scenery* and other works painted years after he had visited the continent, Church departed from the sublime wealth of detail typical of his early productions in favor of more formulaic compositions that suggest the distance and nostalgia with which he had come to view his travels there. His altered perspective on the theme is conveyed here through the generalization of forms, the wistful tone of the warm, hazy light, and details including the well-established city on the distant plateau. His transition from literal record to evocative expression may suggest as well the legacy of his late colleague and traveling companion, Louis Rémy Mignot, whose atmospheric South American scenes had been praised precisely for this suggestive quality.

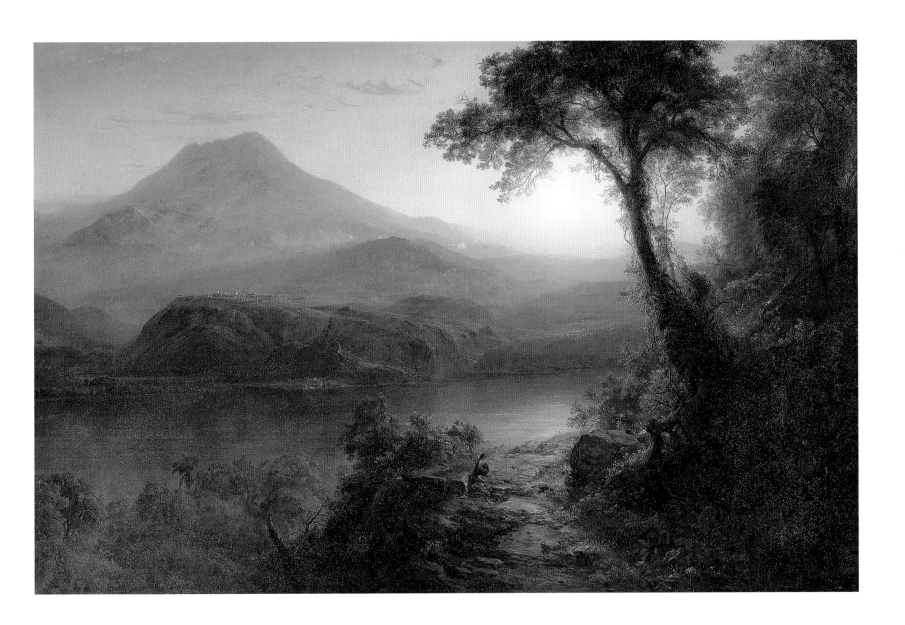

Eastman Johnson

(July 29, 1824–April 5, 1906)

Not at Home (An Interior of the Artist's House), circa 1873

Oil on canvas, 26⁷⁄₁₆ × 22⁵⁄₁₆ inches (67.1 × 56.7 cm)
40.60, Gift of Gwendolyn O. L. Conkling

Eastman Johnson's informal "portrait" of his wife, Elizabeth, shown retreating from a sunlit parlor to the upper floors of their town house, is among the most evocative of the artist's many interior subjects. Particularly in the context of the post–Civil War era, when images of family life were newly poignant, *Not at Home* is unusual for its representation of a solitary female leaving the parlor setting associated in Victorian imagery with her role as "woman of the house" and family caretaker. This and other of the artist's highly personal images from the early seventies—which he preferred not to exhibit—demonstrate Elizabeth's role in the reshaping of her husband's domestic imagery.

Recently married and installed in a new home on West Sixty-fifth Street, Johnson had relocated his studio to the uppermost floor of the house, where he found new, intimist subject matter in his young wife and child, and the spaces they happily inhabited. He achieved his subtly expressive description of this half-lit interior and its mood of peaceful intimacy by drawing on seventeenth-century Dutch interiors, whose complex spaces and narrative use of cast light he fully personalized. This room is distinctive among American parlor images in its relative informality and the implication of regular use. Insomuch as the home was considered at the time to be an expression of the woman who oversaw it, Elizabeth Johnson is portrayed, by extension, as unpretentious. She appears in a voluminous, mauve day dress (appropriate for receiving visitors), which Johnson suggested with a gauzy haze of brushwork culminating in the trailing fabric that catches the light from the parlor.

Not at Home descended in the family through Elizabeth Johnson to their daughter, Ethel, and on to the latter's daughter, from whom the Museum purchased it in 1940.

Francis A. Silva

(October 4, 1835–March 31, 1886)

The Hudson at Tappan Zee, 1876

Oil on canvas, 24 × 42³⁄₁₆ inches (61 × 107.1 cm)
Signed lower left: "FRANCIS A. SILVA. / –'76"
65.10, Dick S. Ramsay Fund

The Hudson River School landscapist Francis Silva achieved his mature manner by the early 1870s, about a decade after he had embarked, essentially self-taught, on his career as a professional artist. *The Hudson at Tappan Zee*, a major work completed in 1876, exhibits the precise composition, neat details, and rich, hazy light typical of his aesthetic and of the idealized realism that continued to hold sway over American landscape art through the nation's centennial year. Although Silva's wide, on-river scenes participated in the evolution of the Hudson River aesthetic away from the early sublime views of the mountainous reaches bordering the river, they nevertheless offered a selective, nostalgic view of the region, focusing on picturesque features of river life set before deep, atmospheric mountain vistas. Thus, although Silva might accurately have depicted the Tappan Zee, then a broad and busy ten-mile stretch of the Hudson between Irvington and Croton Point, as a scene of congestion and activity, he centered his view on two wind-driven schooners and relegated the traffic of a steamer and barges to a more distant plane and significantly smaller scale.

In this particularly spare and serene vista, he employed a broad, horizontal composition in which nearly two-thirds of the canvas is given over to a placid sky infused with yellow light. These evocative effects, carefully crafted by the artist in his studio, were described at the time by the word "sentiment." Silva placed a premium on such expression, as he did on the distinctly American views to which he remained committed at a time when his colleagues increasingly were turning to European subjects and styles.

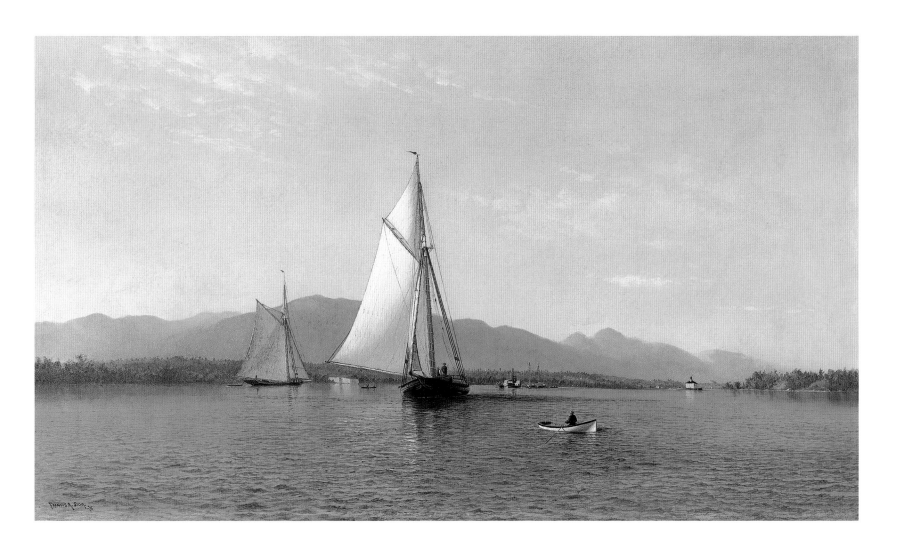

Frank Duveneck

(October 9, 1848–January 3, 1919)

Portrait of a Man (Richard Creifelds), circa 1876

Oil on canvas, 29¾ × 23⅞ inches (75.5 × 60.7 cm)
18.47, Gift of Eleanor C. Bannister

Beginning in the 1870s Frank Duveneck and his American compatriots in Munich embraced a cutting-edge, painterly Realism in their treatment of inventive studio subjects and informal portraits. In keeping with their practice of sharing models and posing for each other, Duveneck completed this sober and rather poignant likeness of his fellow Royal Academy student, the New Yorker Richard Creifelds (1854–1939). He deliberately lent his sitter a wan and disheveled air similar to that of the rough street types whom the young Americans and their German teachers often painted. Duveneck's own student Elizabeth Boott (whom he later married) noted that he was "too realistic to be interesting [*sic*] ever in sentiment, perhaps in fact making things invariably uglier than they are. . . . Ugly always, but the bare startling fact he gives you with such force and truth that it is admirable."[1]

For Duveneck and his peers, however, the actual subject was subordinate to its transformation through the use of an expressive, painterly technique inspired by the vigorous Baroque art of Diego Velázquez and Frans Hals, and by the work of the leading French Realist Édouard Manet. Here Duveneck devoted his attention to the dramatic emergence of the head from the barely defined dark background into a stark, raking half-light. The exceptional confidence of his brushwork is most apparent in the gestural strokes that suggest the sharply lit edge of the white collar. Duveneck's method involved drawing the composition directly on the canvas with a brush, followed by the rapid working of a quantity of rich, liquid paint (Elizabeth Boott commented that "he paints on a puddle in fact") and the finishing of a few selected passages.[2]

1. Quoted in Josephine W. Duveneck, *Frank Duveneck, Painter-Teacher* (San Francisco: J. Howell, 1970), 78.
2. Ibid., 77.

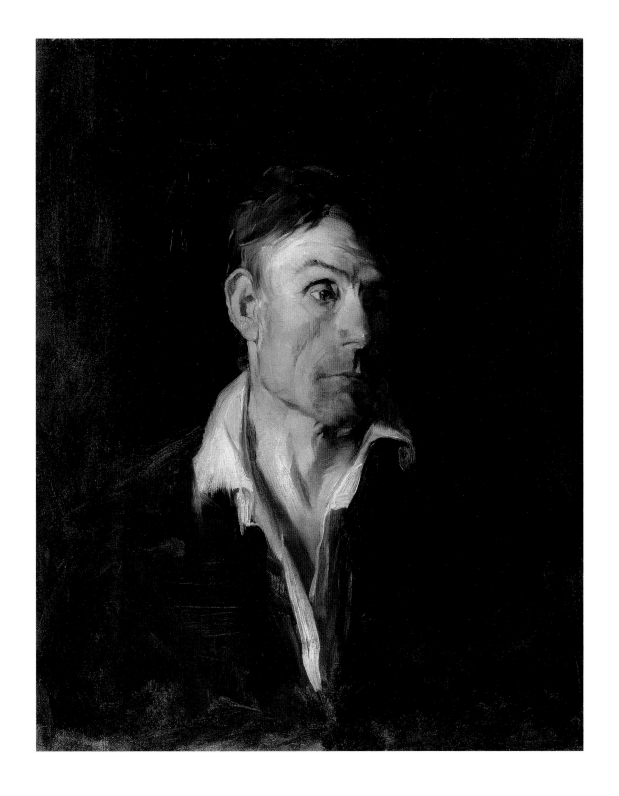

Winslow Homer

(February 24, 1836–September 29, 1910)

In the Mountains, 1877

Oil on canvas, 23⅞ × 38⅛ inches (60.6 × 96.9 cm)
Signed lower left: "HOMER / 1877"
32.1648, Dick S. Ramsay Fund

Perhaps the greatest American Realist of the nineteenth century, Winslow Homer produced a body of works distinguished by their bold compositions and direct record of natural light. Although *In the Mountains* unites a number of the artist's favorite themes (outdoor life and the modern American woman) and pictorial devices (dramatic lines and brilliant effects), it is a relatively unusual work in his oeuvre for its representation of unaccompanied women in a challenging landscape. Homer completed sketches for the painting in the Adirondacks, the locale for which he had abandoned the more touristic slopes of the White Mountains by the late 1870s. Advancing his well-established interest in the sunlit silhouettes of American lady vacationers, he focused on four distinctly independent female hikers; no men are even distantly visible in the image, and no homey lodgings beckon in the valley below.

Homer intensified the narrative by reducing the amount of anecdotal detail and, more important, by employing an elemental composition of two simple, sweeping diagonals that nearly bisect the canvas into triangulated areas of mountain and sky. In designing the canvas he very likely drew inspiration from the spare, decorative compositions of popular Japanese prints, which had attracted his interest since the early years of his career. In this work he also employed particular breadth in rendering the brightly clad figures, forfeiting the lively outlines of his preliminary sketch for the schematic suggestion of the glaring sunlight on their costumes.

Homer appears to have exhausted his interest in the theme of lady tourists by the late 1870s; his subsequent female subjects, and particularly those inspired by the inhabitants of coastal Cullercoats, England, were distinctly more serious, and his later Adirondack subjects were decidedly male in orientation.

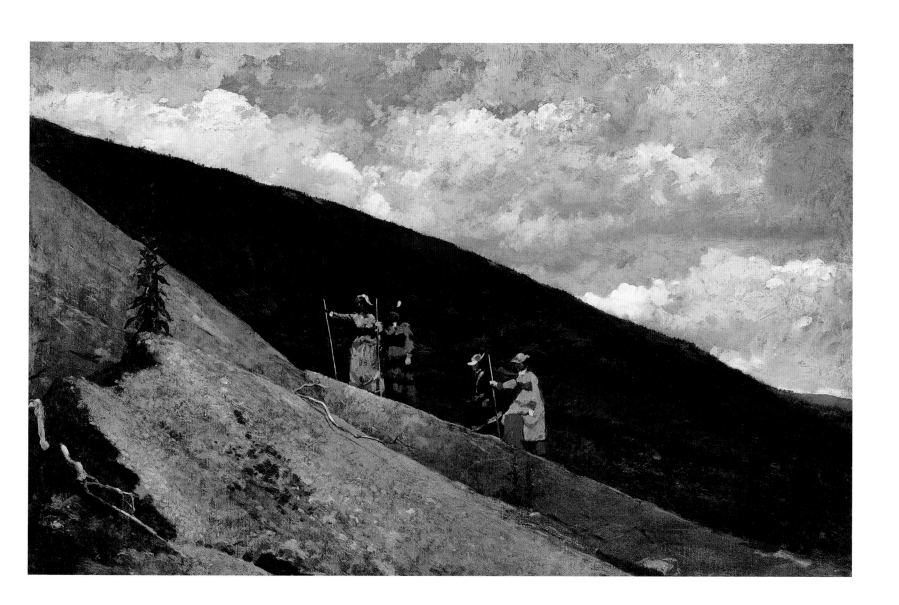

John La Farge

(March 31, 1835–November 14, 1910)

Flowers in a Japanese Tray on a Mahogany Table, 1879

Oil on panel, 10⅜ × 18¹/₁₆ inches (26.3 × 45.8 cm)
2001.47.1, Bequest of Christiana C. Burnett

The Gilded Age painter and decorator John La Farge produced a body of subtle and evocative floral subjects that have long been considered among his finest efforts. Inspired by his passion for the observation of natural forms and shaped by his embrace of Japanese design principles, these are intimate works that suggest some of the transitory sensory appeal of their subjects. Quite distinct from the era's mainstream still-life aesthetic of luxuriant display, they present spare floral arrangements as objects of idealistic contemplation.

Flowers in a Japanese Tray on a Mahogany Table exhibits the self-conscious asymmetry and Asian elements typical of these works, as well as the palpable conditions of light and humidity that render their subjects simultaneously naturalistic and artfully vague. La Farge based his asymmetrical arrangements on elements of Japanese design and orchestrated them with the Asian objects that he collected from the early 1860s; here a delicate Ming bowl and lacquer tray offer a play of volumes paralleled by the juxtaposition of the single camellia in the bowl with the array of blossoms on the tray. Traces of the artist's interest in the vibrant palette of the English Pre-Raphaelites can be seen, but they are muted in this dramatically tenebrous setting, where an oddly gentle raking light from the viewer's space strikes the vessels and flowers, leaving all but the facing surfaces in near darkness. Although La Farge began this seemingly casual composition with a precise preliminary drawing of the essential contours and details, he painted the tumble of languid flowers with intuitive ease, building up the volumes of petals with a painterly touch that nevertheless conveys their velvet fragility.

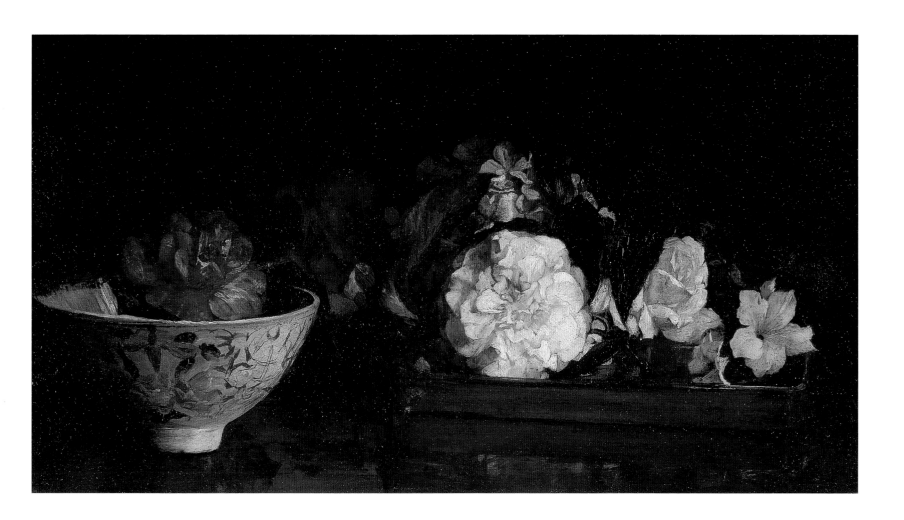

William Michael Harnett

(August 10, 1848–October 29, 1892)

Still Life with Three Castles Tobacco, 1880

Oil on canvas, 10¾ × 15 inches (27.3 × 38.1 cm)
Signed lower left (initials in monogram): "W M HARNETT / 1880"
41.221, Dick S. Ramsay Fund

Working initially in Philadelphia, William Michael Harnett earned his reputation with "masculine" still-life subjects and a clever trompe-l'oeil manner that appealed to an audience of successful merchants and businessmen. Among his favorite themes were the "writing table" and "mug and pipe" pictures in which he employed familiar, worn objects—his studio models—in deliberate arrangements that showcased his virtuosity in the suggestion of varied textures. Harnett previously had painted traditional *vanitas* still lifes in which musical instruments, skulls, and candlesticks served as emblems of human mortality. Although distinctly less morbid, the "mug and pipe" pictures nevertheless offer a narrative centered on the palpable absence of their owner.

In *Still Life with Three Castles Tobacco* the newspaper remains tightly folded, the jug and pipe appear to have been recently put down, and the unstruck match awaits lighting. It remains unclear whether the folded letter was written or received by the absent occupant, although the uncharacteristically mysterious overturned inkwell might suggest the former. Here Harnett's trompe l'oeil has an ironic twist, for the spilled ink mimics the act of the artist's application of paint to the canvas surface. He offers a second witty touch in the contrast of the illegible, schematic newsprint with the letter's legible inscription reading "if this meets with your approval," a deliberate gesture to the viewer. This painting may have been among the handful of Harnetts owned by the well-known New York saloonkeeper Theodore Stewart, whose barroom walls were lined with a collection of paintings and curiosities that entertained his lively and socially mixed clientele.

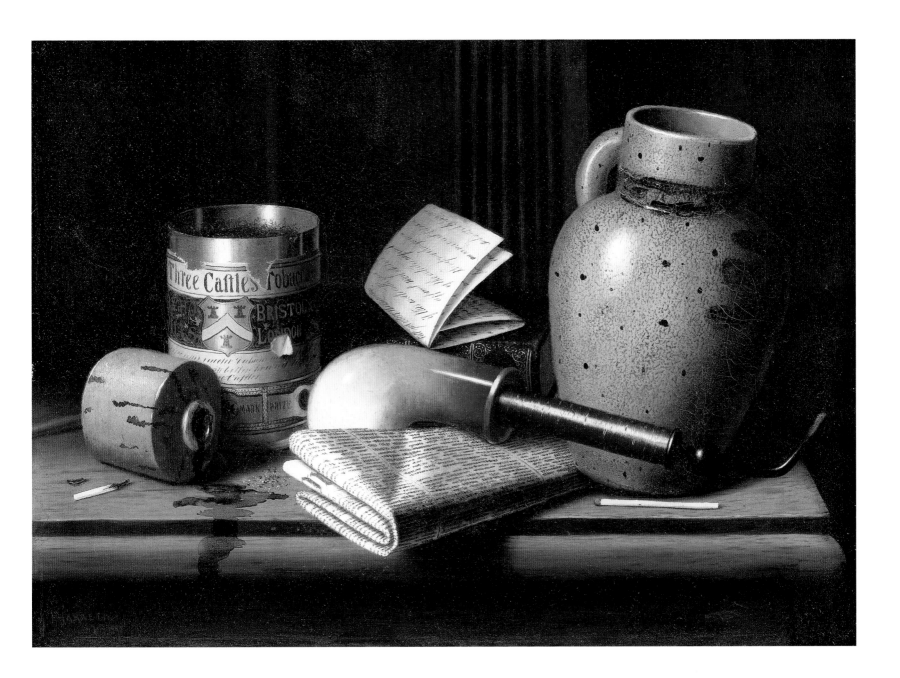

Albert Pinkham Ryder

(March 19, 1847–March 28, 1917)

The Waste of Waters Is Their Field, early 1880s

Oil on panel, 11⁵⁄₁₆ × 12 inches (28.8 × 30.5 cm)
14.556, John B. Woodward Memorial Fund

An early example of the highly imaginative moonlit marine subjects for which Albert Pinkham Ryder was eventually best known, *The Waste of Waters Is Their Field* demonstrates the artist's proclivities for dramatic simplification of form and expressive use of light. Ryder's interest in marine subjects has been linked both to his early years in the coastal town of New Bedford, Massachusetts (where several accomplished marine painters were at work) and to the transatlantic sea voyages that the artist made beginning in the late 1870s. In keeping with the Romantic tradition in art and literature, Ryder developed his marines into narratives addressing the relentless character of preordained fate, often employing titular references to well-known literary works. Ryder may have derived the title of this image from the poem "Madoc" (1805) by the English poet Robert Southey—an account of a medieval Welsh prince's arduous ocean passage to America. As the voyage wears on, Southey describes "a weary waste of waters" whose monotonous immensity nearly overcomes Madoc and his party.

Ryder distilled this composition into opposing zones of dark sea and half-lit sky, with the horizon broken at the left by the rising form of the ship and figures, and at the right by the jutting angle of the mast and sail; the paired angles create a strong sense of movement seconded by the active forms of the clouds in the sky. He added a more mysterious touch with the delicately tenuous rope line that connects the figures to the sail. Inspired by the expressive, painterly facture of French Barbizon landscapes, Ryder built up the painting surface with his customary heavy touch, employing a sweeping, impastoed application in the sky. Although this work, along with numerous others in his oeuvre, has become somewhat difficult to read owing to a darkening of the surface, the effectively abbreviated composition retains its dramatic force.

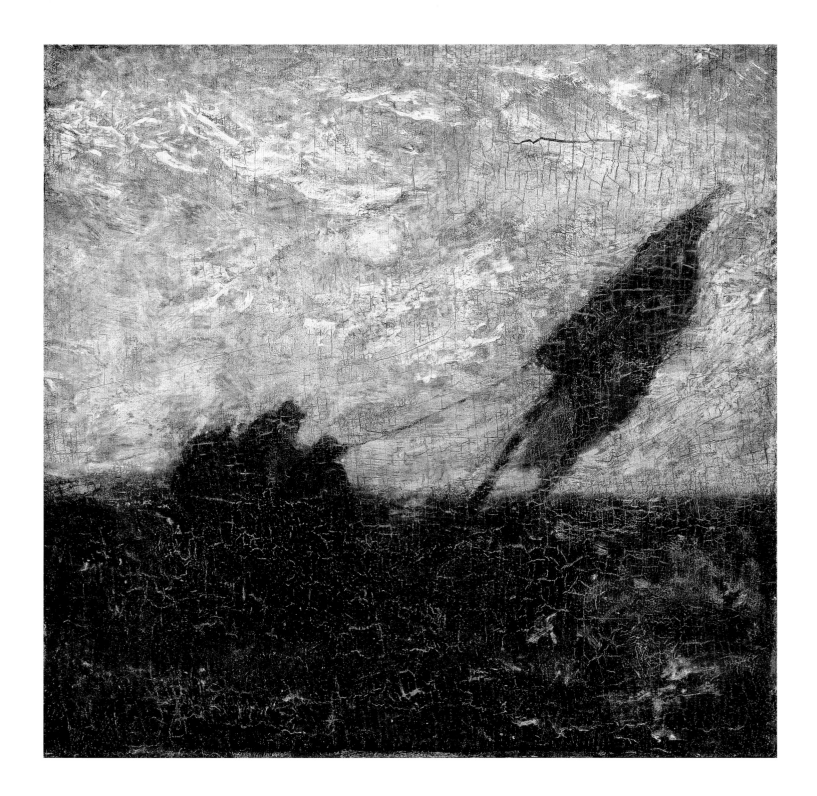

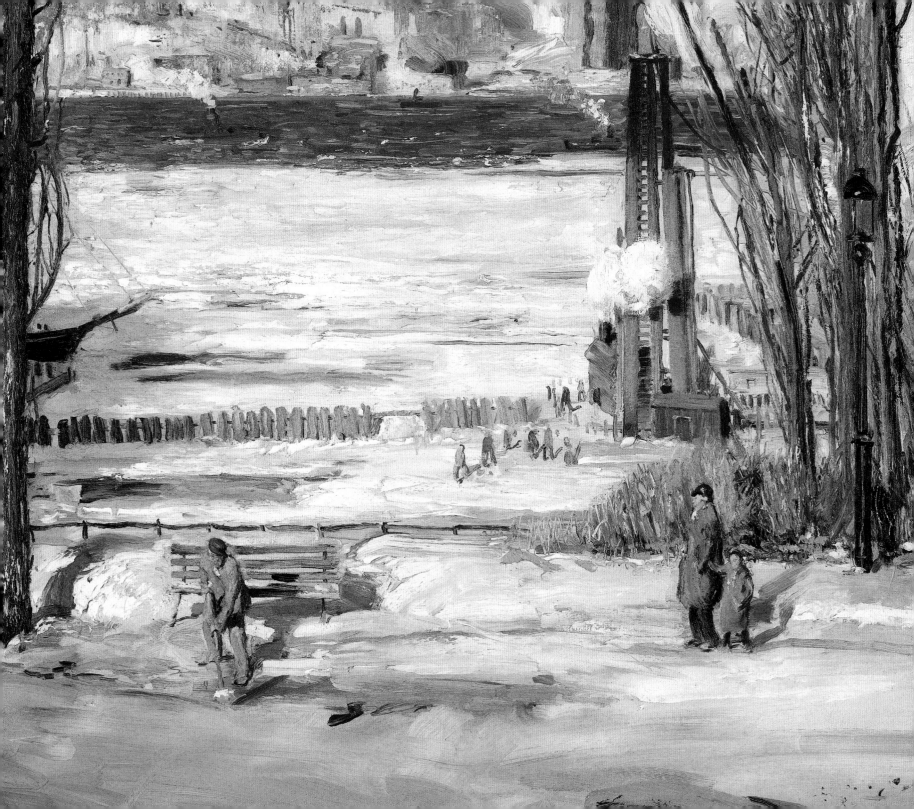

Remaking the American Image
Cosmopolitan Painting at the Turn of the Century

By THE LATE 1870S, THE PREDOMINANT PROFILE OF THE AMERICAN artist had changed dramatically. For at least the next three decades, the majority of painters would seek their formal training in European art capitals, adopting academic methods and cosmopolitan studio life, and traveling to new international destinations for their subject matter. Many of these artists found the European environment so stimulating and sympathetic to their creative goals that they chose to remain abroad for the duration of their careers; Daniel Ridgway Knight found the entirety of his subject matter in France, for example, whereas Edwin Lord Weeks used Paris as a home base for travel to such distant regions as North Africa and India. Most of these cosmopolitan painters also followed in the path of their European contemporaries in establishing evocative studio spaces, appointed with fashionable art and bric-a-brac indicative of their wide-ranging aesthetic sensibilities.

In the course of their European educations, American artists gravitated to Realist styles of one type or another; the polished verism of academic Realism was prevalent in Parisian schools, while a more vigorous, Baroque-inspired naturalism came to characterize the Munich training of the period. During their sojourns or residencies abroad, American painters also encountered avant-garde aesthetics outside the confines of academies and subsequently integrated elements of such styles as Impressionism and Post-Impressionism into their own practices. For some, including Theodore Robinson and Childe Hassam, this process involved identifying American subjects that were in one way or another parallel to the pictorial motifs—rural and urban—embraced by the French Impressionists.

Vying with these strong Realist trends throughout the Gilded Age was a strain of ideal art based in the classically inspired forms of the Italian Renaissance and the nineteenth-century French Beaux-Arts style. Its practitioners envisioned an art centered on refinement and lofty expression, and to that end labored to perfect ideal figure styles and complex compositions, often derived from the religious art of earlier centuries, in the service of American civic and cultural ideals.

With academic styles of all stripes increasingly viewed as staid and conservative after 1900, American Impressionism firmly established itself as the dominant aesthetic and held sway until well after 1910. The Manet-inspired Realism of the Ashcan painters followed close on its heels after a highly publicized "debut" at New York's Macbeth Galleries in 1908. Although both of these aesthetics were equally derivative of French art, it was the bracing urban Realism of Robert Henri and his followers that ultimately was regarded as the more quintessentially American expression of the moment. In tune with the irrepressible dynamism and rough, risqué character of modern New York, the Ashcan aesthetic inadvertently emerged from the shadow of its European origin in a way that the avant-garde abstractions of the succeeding generation of American painters never would.

Detail, ill. p. 147

William Merritt Chase

(November 1, 1849–October 25, 1916)

Studio Interior, circa 1882

Oil on canvas, 28¹⁄₁₆ × 40⅛ inches (71.2 × 101.9 cm)
Signed lower left: "Wm M Chase"
13.50, Gift of Mrs. Carll H. de Silver in memory of her husband

One of the most successful painters in late nineteenth-century America, William Merritt Chase was a leading New York personality whose reputation was much enhanced by the opulent studio space pictured here, in which he worked and promoted his art. First inspired by the exotically appointed studios of his European contemporaries during his student years abroad, Chase embarked on his own collecting forays, returning to New York with a booty of paintings, antique furniture, textiles, metalwork, ceramics, and frames. In 1879 he claimed the Tenth Street Studio Building's largest space (once occupied by the irrepressible Albert Bierstadt) and installed his splendid furnishings in a manner befitting an ambitious, cosmopolitan artist. The space became the haunt of colleagues, patrons, and a broader public, to whom it was opened on a weekly basis, as well as the much-publicized setting for musicales and artistic balls.

Chase undertook the subject of the studio in a number of paintings in which he addressed the idea of engagement with art. Characterized by a rich palette and animated execution, these images constitute the pictorial equivalent of his atelier's lavish accretion of objects. They held enormous appeal for an American audience increasingly under the sway of the British Aesthetic Movement, which above all championed the artistic appointment of interiors with a rich ensemble of decorated surfaces. Here Chase represented a portion of the main "gallery," where a young woman in fancy dress pages through a folio of pictures. Above her, at the right, hangs a reproduction of the portrait *Malle Babba*, circa 1725–50 (The Metropolitan Museum of Art, New York), a copy believed at the time to be by Frans Hals, on whose vigorous realism Chase had modeled his own technique. That influence is visible here in the lively brushwork, as well as in the flickering color with which he suggested the brilliant light that would have flooded through the north-facing windows of the studio.

Chase sold *Studio Interior* to Thomas A. Howell, a sugar refiner and prominent New York collector, from whom it was purchased by Carll H. de Silver, a Brooklyn collector and leading Museum trustee. Chase ultimately closed his studio in 1895 and consigned his collection of nearly two thousand objects for sale.

Edwin Lord Weeks

(1849–November 16, 1903)

Old Blue-Tiled Mosque, outside Delhi, India, circa 1883–85

Oil on canvas, 31⁵⁄₁₆ × 25½ inches (79.6 × 64.8 cm)
15.300, Gift of George D. Pratt

An intrepid traveler and indefatigable observer, the American expatriate Edwin Lord Weeks earned his reputation with vivid North African and Middle Eastern subjects, and with his many paintings of the less-often-explored reaches of India. It was partly his fascination with the Islamic architecture of Morocco and Spain that led Weeks to seek out the monuments of Indian architecture that were increasingly well documented by photographers of the period. He made three extended visits (1882–83, 1886–87, and 1892–93) to India, where he compiled innumerable sketches for his vibrant and meticulously elaborated paintings of Indian life.

In this image of two armed men (described as Afghans in a 1905 catalogue) encountering an old man before the weathered façade of a mosque, Weeks employed a dynamic transcription of reflected light and cast shadows to enliven a subject that nineteenth-century critics might otherwise have found coarse or uninteresting. The artist openly acknowledged the importance of setting to the success of his paintings, noting that few observers would be drawn to the particularities of the Indian population in the absence of such diverting architectural elements. Here he chose an especially colorful, small-scale mosque, whose sheathing of blue, yellow, green, and orange tiles has largely fallen away. Weeks's combination of strict attention to detail with a careful breadth of touch was probably shaped in part by his use of photography as a visual aid. Throughout the image he employed a dense layering of tones to achieve intricate modulations of light and accurate suggestion of color, establishing the geometry of the tile design through patterns of summary touches. A certain roughness in the texture of even the finest details enhances the sense of a naturalistically variable light, a quality that distinguishes Weeks's orientalist subjects from those of the French academician Jean-Léon Gérôme.

Old Blue-Tiled Mosque, outside Delhi, India was presented to the Museum in 1915 by the important Brooklyn collector George D. Pratt, who had purchased it at the artist's 1905 estate sale. The gift represented a concerted effort by the Museum's early supporters to build the American collection.

Ralph Albert Blakelock

(October 15, 1847–August 9, 1919)

Moonlight, circa 1885–89

Oil on canvas, 27$\frac{1}{16}$ × 32 inches (68.7 × 81.3 cm)
Signed lower right (in arrowhead): "R.A. Blakelock"
42.171, Dick S. Ramsay Fund

During the late 1880s, at the height of his powers, Ralph Blakelock painted the dramatically expressive moonlight subjects in which he achieved a decorative refinement and full command of his distinctive technique. These were the works sought by discerning collectors during the 1890s and held up as proof of the painter's genius after his confinement in 1899 owing to mental illness. In this remarkable example Blakelock combined the moonlight theme with a Native American narrative (including a lone, mounted figure beneath the tallest tree), thus lending the work an emphatically American character and an air of Romantic nostalgia.

Although Blakelock found inspiration for his moonlight subjects in the works of his contemporary Albert Pinkham Ryder, his technique was distinct and original, and so idiosyncratic that his art became the subject of some mythologizing; his wife apparently suggested that he based one moonlight subject on the irregular pattern of color in a chipped zinc bathtub. His visual sources were certainly more complex, however, and included work by such Barbizon painters as Théodore Rousseau and Jules Dupré. Blakelock prepared his canvases with a layer of thick, textured impasto, on which he painted the composition in successive, thin layers of color (often sanded with pumice), creating a sense of intricate irregularity and vibration in the dramatic silhouettes of the trees. Here he achieved an unusually resolved and thoroughly decorative arrangement of the dark foreground forms, which act as a screen through which one views the vague, distant landscape. Blakelock sold this *Moonlight* to the vaudeville actor Lew Bloom, a loyal patron well before the artist's institutionalization and the ensuing sensational interest in his work.

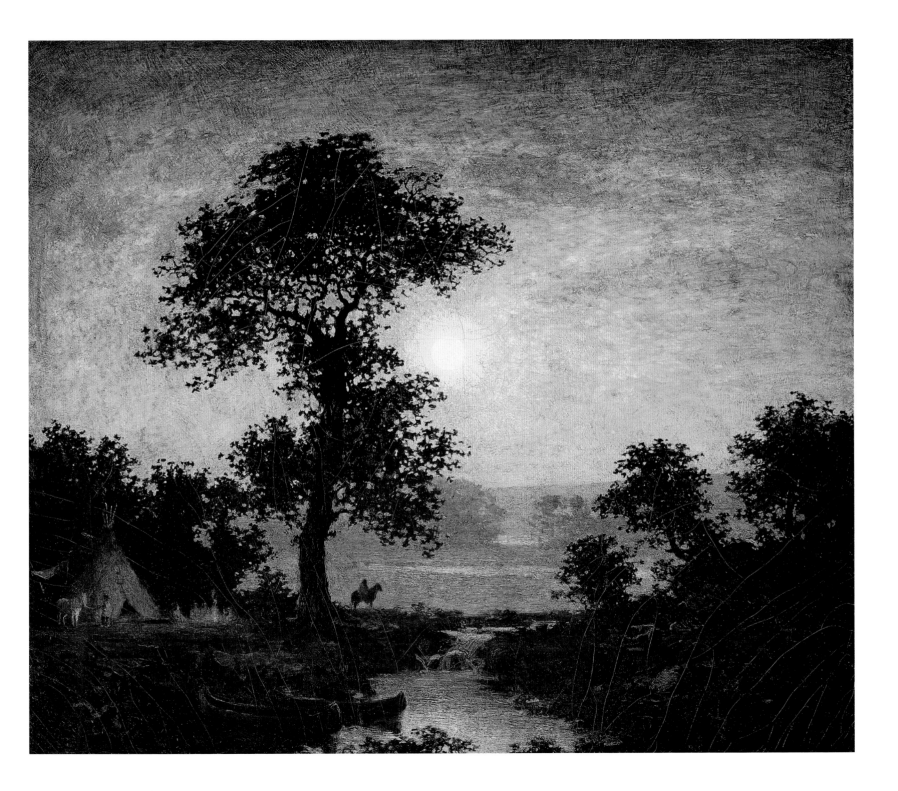

Stacy Tolman

(January 28, 1860–January 20, 1935)

The Musicale, 1887

Oil on canvas, 36¼ × 46 inches (92 × 116.9 cm)
Signed lower left (traced over weaker signature): "Stacy Tolman / 1887"
51.211, Dick S. Ramsay Fund

"Musicales" were extremely popular among late nineteenth-century Americans who sought to cultivate an artistic life-style. For painters of the period, music-making was a subject with an immediate parallel to the artistic process, often presenting the occasion for a self-portrait of the "artist as musician" within the scene. Such is the case in Stacy Tolman's *The Musicale*, set in the Boston studio that he shared with the painter-etcher William Henry Bicknell. Tolman, a violinist, appears to have modeled the central figure as a self-portrait; Bicknell, a talented cellist, appears at the right.

The Musicale is something of a departure among American recital paintings. Removed from the highly controlled setting of the domestic interior and placed within the confines of an artist's studio, the subject takes on a more bohemian character. Here the effect is even more pronounced because of the nature of this very informal and sparsely appointed studio, which suggests a pure dedication to artistic expression; in addition to the unmatched chairs and tables and the piano, the "furnishings" include folios of drawings and music, and the artists' own paintings and props (including a miscellaneous assortment of cloths, bottles, and folded parasols). The well-worn screen behind the string players suggests an equally modest and unconventional living space adjoining the public space. Tolman's broad touch and naturalistic approach to the description of light derive from the Realist style of his Boston teacher Dennis Miller Bunker. The clear, pale light and muted colors distinguish the scene from more typical, tenebrous studio paintings of the period. The palms and parasols suggest a vaguely japoniste taste, echoed in the decorative compositions of the paintings on the wall.

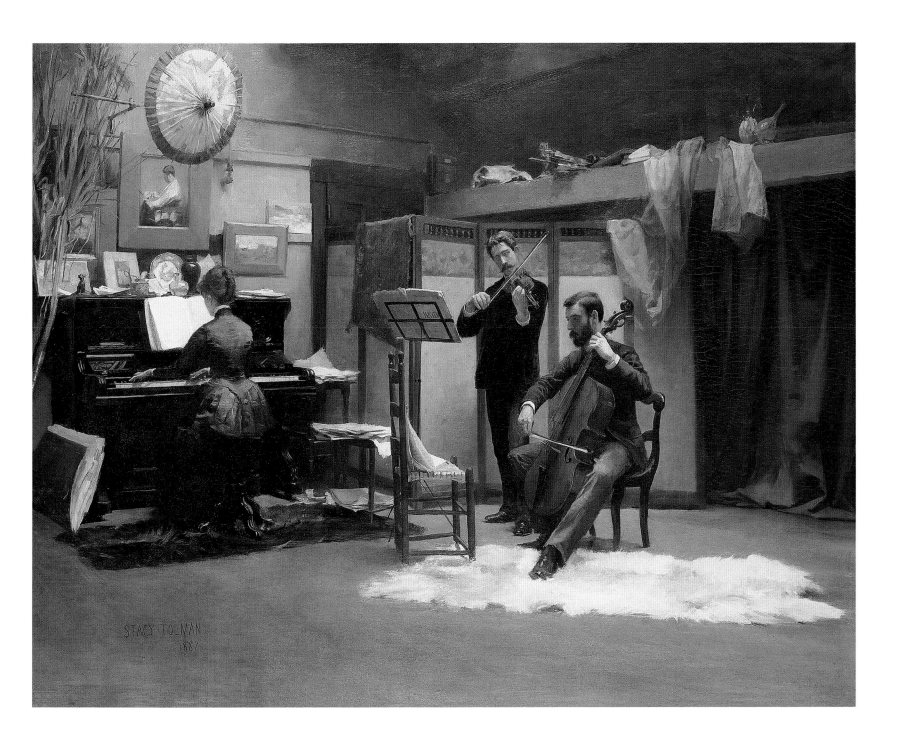

George Inness

(May 1, 1825–August 3, 1894)

Sunrise, 1887

Oil on canvas, 30¹⁄₁₆ × 45¹⁄₁₆ inches (76.3 × 114.5 cm)
Signed lower left: "G. Inness 1887"
41.775, Bequest of Mrs. William A. Putnam

In the late 1880s, after long years of work, the landscape painter George Inness infused his art with new individuality and an intensified expression of the Swedenborgian theories he had long espoused. From the time of his introduction to the teachings of Emanuel Swedenborg in the 1860s by the fiery Brooklyn preacher Henry Ward Beecher, Inness viewed the primary subject of his art to be "the visible expression of a strongly felt emotion."[1] His aesthetic accordingly moved from the transcription of factual details toward a highly emotive, atmospheric tonalism and pictorial "unity" that he believed both embodied and conveyed the spiritual presence animating the world.

As in the majority of his canvases from the 1880s, Inness's use of an enveloping, high-key tonal atmosphere in *Sunrise* represented a step away from objective reality, transforming solid objects into evanescent forms and atmosphere into a palpable substance. Here a single ethereal tree dominates the refined composition, while two unlikely smokestacks (probably modeled on those at the printing factory near the artist's home in Montclair, New Jersey) emerge from the distant haze, and a weightless female figure appears at the side of the brook that flows directly to the factory building. The manner in which Inness integrates such details into an otherwise bucolic setting suggests his ideal view of human labor and industry.

Sunrise was one of numerous works by Inness collected as investments by Richard H. Halsted and sold as a group shortly after the artist's death (and notably before Inness's own estate sale). It was purchased from the sale by the leading Brooklyn collector William A. Putnam.

1. *"The Sign of Promise." By George Inness. Now on Exhibition at Snedecor's Gallery, 768 Broadway, New York*, n.d., as cited by Nicolai Cikovsky in Montclair Art Museum, New Jersey, *George Inness: Presence of the Unseen* (Montclair, 1994), 19.

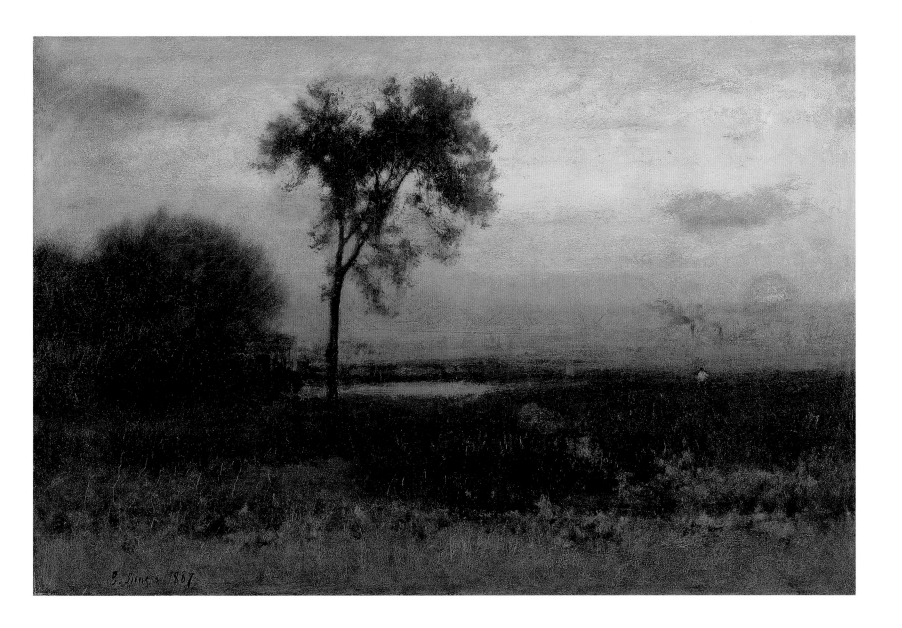

Alexander Pope

(March 25, 1849–September 9, 1924)

Emblems of the Civil War, 1888

Oil on canvas, 54³⁄₁₆ × 51⅛ inches (137.6 × 129.8 cm)
Signed lower right: "ALEX—POPE—88 / —BOSTON—"
Inscribed on calling card lower left: "Mr. Alexander Pope"
66.5, Dick S. Ramsay Fund, Governing Committee of The Brooklyn Museum, and Anonymous Donors

Emblems of the Civil War is one of a number of hieratic still-life arrangements in which the trompe-l'oeil painter Alexander Pope emulated the current custom of memorial displays of military souvenirs. Increasingly popular during the post–Civil War decades, both the displays themselves and paintings like this one commemorated the war dead while they inadvertently evoked the growing remoteness of the conflict. With surviving members of the Civil War generation ever fewer in number, the materiality of soldiers' relics underscored the passing of these witnesses to history as well as the lives lost in battle.

Pope apparently undertook this work on commission from the family of the Civil War veteran Major General William Badger Tibbits, of Hoosick, New York, nearly eight years after the latter's death. The objects in the painting, including the crossed pistols, Zoave rifle, Union cap, and dress swords, were indeed the mementos of Tibbits's valiant service with the Second New York Cavalry of the Union army. Pope also included the interesting details of the Confederate bullet on a string and a key labeled "Libby Prison," in reference to the infamous Confederate prison in Richmond, Virginia. The precise symmetry and angularity of the composition and the solid illusionism of the forms contribute to the sober character and memorial weight of the painting. Pope also offered some lighter, witty touches in the form of the white calling card bearing his name and the small "doodle" of a face at the upper left.

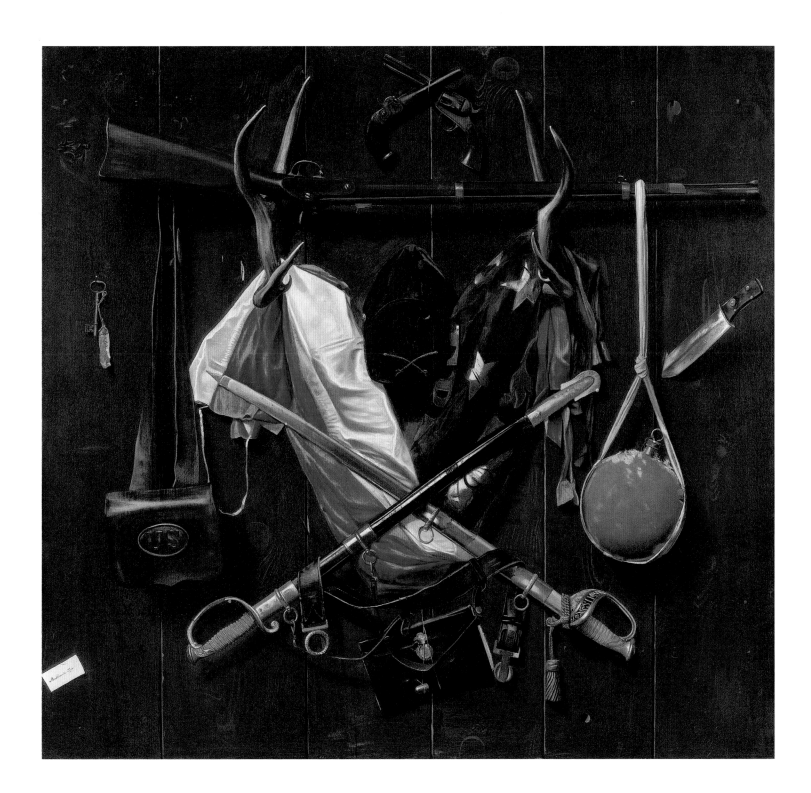

Thomas Eakins

(July 25, 1844–June 25, 1916)

Letitia Wilson Jordan, 1888

Oil on canvas, 59¹⁵⁄₁₆ × 40³⁄₁₆ inches (152.3 × 102 cm)
Inscribed lower right: "TO MY FRIEND / D.W. JORDAN. / EAKINS.88"
27.50, Dick S. Ramsay Fund

Pursuing most of his figure and portrait paintings independent of commissions, Thomas Eakins sustained an intense commitment to a probing Realist aesthetic unmatched by his American peers. This arresting and exquisitely painted likeness of Letitia Wilson Jordan (1852–1931), the sister of his pupil David Wilson Jordan, was instigated by Eakins the morning after he had seen her in this costume at a ball. Over the course of extended sittings, he recorded her appearance in the gauzy black gown, Japanese shawl, buff gloves, and red bow with unremitting directness—a quality perceived by his Gilded Age audience as bluntness, and by modern viewers as poignant factuality. To intensify the immediacy of Letitia Jordan's presence, he set her figure against a plain dark background and cast onto it an intense, theatrical light that was inspired in part by the dramatic masterworks of the seventeenth-century Spanish artist Diego Velázquez.

As taken as he was with her costume, Eakins was, as always, even more attentive to the physicality of his sitter's body, a predilection visible here in the blatant bareness of the upper arms and strong volume of the neck. As seen by Eakins, there was an uneasy alliance between Letitia Jordan's figure and her clothing—a sense exaggerated by the bulkiness of her wrinkled gloves, the flimsiness of the black gauze against the firm structure of her white shoulders, the constraint of the scarlet ribbon around her neck, and the disembodied vacancy of her gaze.

Eakins gave the portrait to David Wilson Jordan. Letitia Jordan went on to marry the Connecticut clergyman Leonard Woolsey Bacon. The taste for Eakins's art had not yet grown to outright admiration by the time the Museum purchased this work in 1927, leading the curator at that moment to comment apologetically for what he described as the artist's repellent treatment of the feminine type. He suggested, however, that this quality was outweighed by Eakins's expression of his sitter's more significant personal traits.

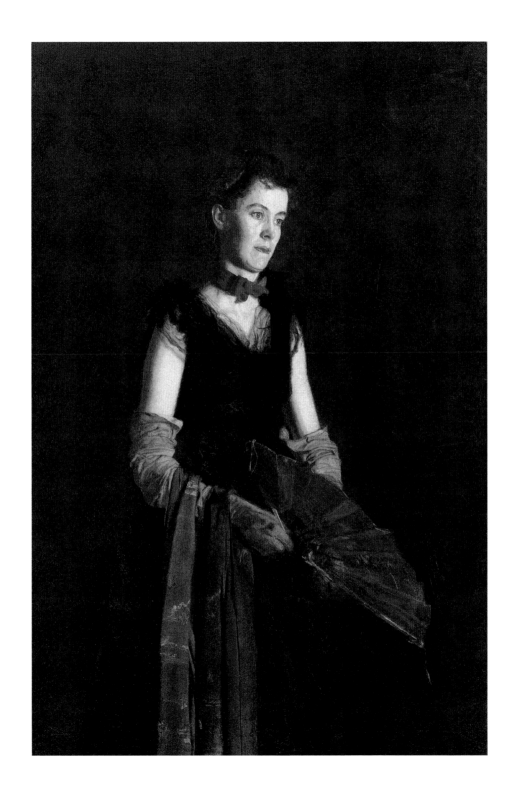

John Singer Sargent

(January 12, 1856–April 4, 1925)

An Out-of-Doors Study (also known as *Paul Helleu Sketching with His Wife*), 1889

Oil on canvas, 25¹⁵/₁₆ × 31¾ inches (65.9 × 80.7 cm)
Signed lower right: "John S. Sargent"
20.640, Museum Collection Fund

A leading force in the revival of society portraiture in Britain and America at the end of the nineteenth century, John Singer Sargent also created compelling landscape and genre subjects. Among the most interesting of the latter are the canvases he painted over the summer seasons of 1885 through 1889 in England, where he engaged in his most intense experiments with pleinairism as a respite from the demands of formal portrait work. Ultimately joining the Broadway artists' colony in the Cotswolds, Sargent worked in nearby Fladbury in 1889. He was joined there by visitors including the French painter Paul César Helleu (1859–1927) and his young wife, Alice Louise (née Guérin), whose presence he commemorated in this precisely composed but freely brushed canvas that he titled *An Out-of-Doors Study*.

As his title indicates, Sargent's overriding concern in this informal portrait of the Helleus was the issue of technique, and of plein-air work in particular. Drawn to experiment with Impressionist facture in his work outdoors, Sargent nevertheless adhered here to an emphatic compositional structure dominated by the stable triangle formed by the two figures. He mediated this structural underpinning through his use of slashing strokes of light color, which superficially emulate the canonical Impressionism practiced by Claude Monet and, thereby, the spontaneity associated with it. Although *An Out-of-Doors Study* is nominally and referentially about plein-air work, particularly in representing Helleu in the act of painting a plein-air study (which may in turn be a study of Sargent pursuing the same activity), the canvas appears to have been completed in the studio, where Sargent probably relied on a photograph in which Paul and Alice Helleu are similarly posed.

This was one of five paintings that Sargent brought with him to the United States in December 1889 to exhibit in a deliberate bid for recognition outside the genre of formal portraiture. It was purchased for the Museum in 1920 after the director William Henry Fox encountered it in Helleu's home and studio in Passy (near Paris) and made an offer for it on the spot.

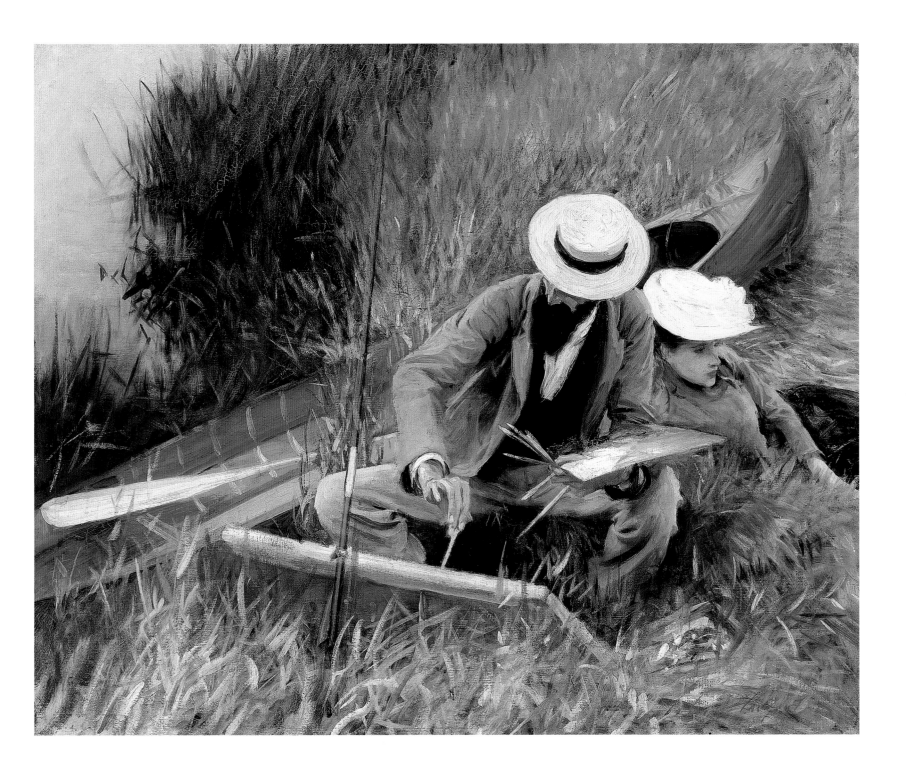

Theodore Robinson

(June 3, 1852–April 2, 1896)

The Watering Pots, 1890

Oil on canvas, 22 × 18¹⁄₁₆ inches (55.9 × 45.8 cm)
Signed lower right: "Th. Robinson / 1890"
21.47, Museum Collection Fund

A Paris-trained artist and intimate of the great French Impressionist Claude Monet, Theodore Robinson was among the first Americans to practice an Impressionist aesthetic. *The Watering Pots* is one of several canvases in which Robinson represented his model Josephine Trognon near an open cistern in a Giverny garden. In a manner typical of his own brand of Impressionism, he set the solidly defined figure and geometric forms of the well and watering pots in a setting rendered in a fully Impressionist manner, with broken brushwork approximating the evanescent effects of light.

Robinson's hybrid aesthetic stemmed in part from his use of photography as a compositional aid throughout his years of Impressionist work in France when he could little afford to hire models on a regular basis. His method entailed the transferral of a photographed composition to canvas by means of a scored drawing, followed by the completion of the painting in the original plein-air setting. Robinson's light palette and staccato brushwork led progressive American critics to link his work to the much-admired paintings of Claude Monet and Camille Pissarro. Noting the American's ability to capture "a brilliantly natural effect of out-of-doors light and atmosphere," one writer commented, "The impression is what Mr. Robinson gets from nature, and . . . he succeeds in communicating it to his spectator."[1]

Robinson sold this work directly to Frank L. Babbott, an enlightened philanthropist and art patron, and later president of The Brooklyn Institute of Arts and Sciences. A regular visitor to the artist's New York studio from 1891, Babbott apparently had a taste for Robinson's bright French subjects. Following one of Babbott's visits in 1893, just before he purchased *The Watering Pots*, Robinson noted in his diary, "[H]e is daft on sunlight effects, and likes some of mine very much."[2]

1. "The Academy of Design," *American Art Review* 24, no. 3 (January 1890): 31.
2. Theodore Robinson, December 8, 1893, "Diary 1892–1896," Frick Art Reference Library, New York.

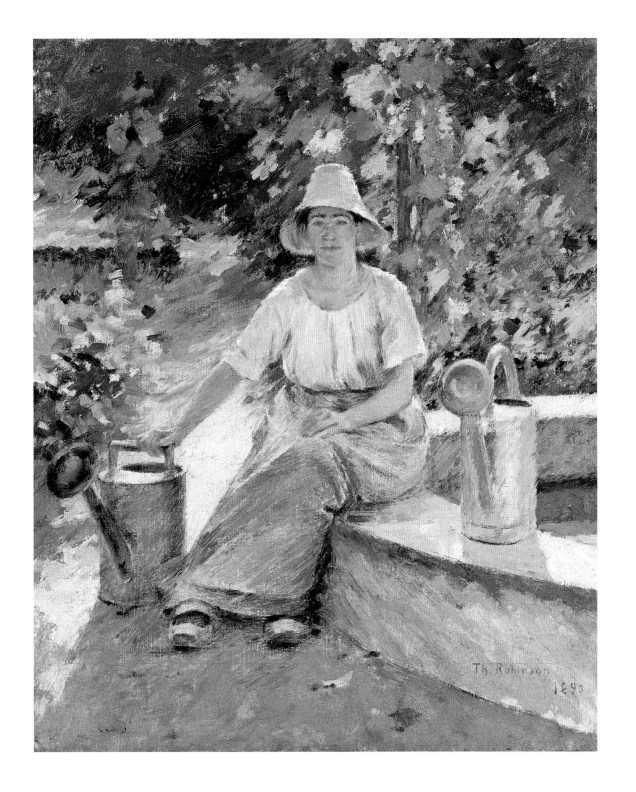

Elihu Vedder

(February 26, 1836–January 29, 1923)

Soul in Bondage, 1891–92

Oil on canvas, 37¹³/₁₆ × 24 inches (96.1 × 60.9 cm)
Signed lower right: "ELIHU VEDDER / ROMA / 1891"
Signed lower left (initial in monogram): "V"
47.74, Gift of Mrs. Harold G. Henderson

Elihu Vedder, a longtime expatriate in Italy, was ultimately best known for works such as *Soul in Bondage*, in which he combined enigmatic subject matter and a decorative aesthetic in the spirit of fin-de-siècle Symbolism. When Vedder recorded the sale of *Soul in Bondage* in 1891, he wrote, "This was what I call an important picture."[1] The painting indeed remarkably combines and distills the artist's classicizing figure style, the more abstracted designs he developed in his illustrations for the English edition of Edward FitzGerald's *Rubáiyát of Omar Khayyám* (1884), and his thematic focus on the individual's spiritual conflict with predestined fate. The artist's wife, Carrie, described this figure as a soul, turned from the light, who might be freed if she were to choose good over evil—symbolized, respectively, by the yellow butterfly and blue serpent in her hands.

Soul in Bondage strikingly embodies the formal complexity and expressive intensity of Vedder's work of the nineties.

Here he framed the figure with his abstracted "double swirl," a motif he described as "the gradual concentration of the elements that combine to form life; the sudden pause through the reverse of the movement which marks the instant of life; and then the gradual, ever-widening dispersion again of these elements into space."[2] The concentric, arcing bands provide an ethereal backdrop for the smooth, elongated figure and echo the enclosing forms of the wings and abstracted drapery. The juxtaposition of the seamlessly modeled, sculptural form of the body and the surrounding network of linear patterning reveals Vedder's significant debt to the English Pre-Raphaelite painter Edward Coley Burne-Jones.

1. Elihu Vedder, *The Digressions of V.* (Boston: Houghton Mifflin Co., 1910), 487.
2. From Vedder's undated, unpaginated manuscript, "Notes for Preface to Omar Khayyam Drawings," The American Academy of Arts and Letters, New York; as quoted in National Collection of Fine Arts, Washington, D.C., *Perceptions and Evocations: The Art of Elihu Vedder* (Washington, D.C.: Printed for the National Collection of Fine Arts by the Smithsonian Institution Press, 1979), 132.

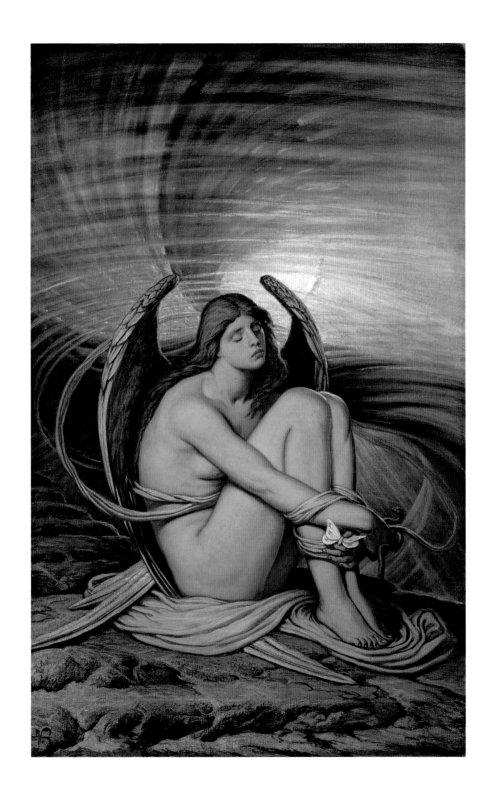

William Merritt Chase

(November 1, 1849–October 25, 1916)

Lydia Field Emmet, 1892

Oil on canvas, 72 × 36⅛ inches (182.9 × 91.8 cm)
Signed lower left: "Wm M. Chase."
15.316, Gift of the artist

This dramatic full-length likeness of his prize pupil Lydia Field Emmet (1866–1952) is considered to be one of William Merritt Chase's most striking essays in portraiture. Assertively broad in handling and challenging in expression, the painting was undertaken on Chase's own initiative and constitutes an homage to such artistic exemplars as Édouard Manet, Diego Velázquez, and James McNeill Whistler. By the time that Chase painted her, Emmet had become a trusted teacher in his Shinnecock summer school. She had previously trained in Paris at the Académie Julian and then worked as an illustrator and decorative designer before resuming her studies under Chase at the Art Students League in New York. By 1900 she would be established as a portrait painter specializing in children.

In portraying Emmet, Chase embraced the model of self-possessed womanhood embodied in such works by Manet as *Young Lady in 1866 (Woman with a Parrot)*, 1866, already in the collection of the Metropolitan Museum of Art at the time. The influence of Manet's starkly broad execution, as well as the impact of the high-contrast, painterly brilliance of the Spanish Baroque portraits of Velázquez, is evident in Chase's virtuoso description of the lace edging of Emmet's dress and

his nearly gestural suggestion of the trailing pink bow at her back. Chase appears to have derived the pose from his friend Whistler's *Arrangement in Black and Brown: The Fur Jacket*, 1877 (Worcester Art Museum, Massachusetts); in both works the sitter's gaze is directed over her shoulder and a bent elbow pushes illusionistically into the viewer's space in a manner suggesting a certain disregard for formal address. Emmet's unabashedly forward and foreshortened elbow is loosely modeled to an assertive pink point. Chase rendered the face with a brushy vagueness typical of his portraits without diminishing the sense of his young sitter's independence. Her subtly delineated gown of striped black satin, trimmed in a revival style known as Van Dyckian, offered an additional reference to the grand Baroque portraits from which this work essentially derives.

After its debut at the Society of American Artists exhibition of 1892, *Lydia Field Emmet* was included in the display of American paintings at the Chicago World's Columbian Exposition of 1893, where it coincidentally was hung on the same wall as Whistler's *Arrangement in Black and Brown: The Fur Jacket*. The portrait was presented to the Brooklyn Museum by Chase himself.

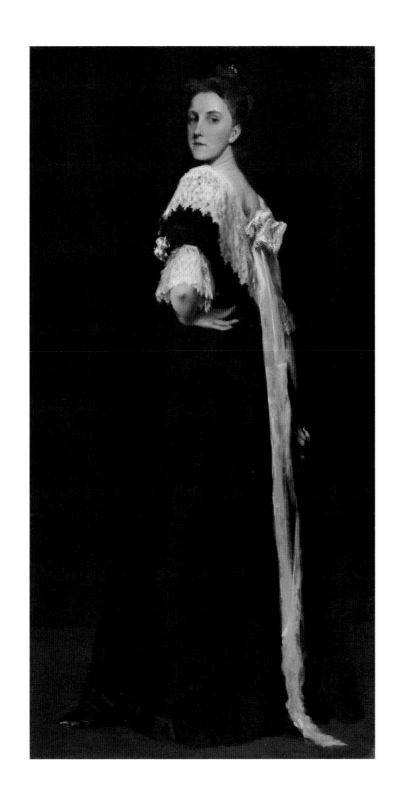

John Henry Twachtman

(August 4, 1853–August 8, 1902)

Meadow Flowers (Golden Rod and Wild Aster), circa 1892

Oil on canvas, 33⁵⁄₁₆ × 22³⁄₁₆ inches (84.6 × 56.3 cm)
Signed lower left: "JH Twachtman"
13.36, Caroline H. Polhemus Fund

John Twachtman, an American Impressionist, was known for decorative compositions evocative of the more intimate moods of nature. He extended his repertoire to floral subjects in the early nineties, after he had established a residence in Greenwich, Connecticut. The gardens and outlying grounds on his Round Hill Road property proved to be a rich source of inspiration. Although he painted such cultivated garden varieties as tiger lilies, he appears to have been particularly drawn at this time to the phlox, asters, and other wildflowers that flourished beyond his garden beds. Of all his flower paintings, *Meadow Flowers (Golden Rod and Wild Aster)* is among the most daring in its abstracted composition and expressive execution.

Employing a vertical format akin to decorative Chinese scroll paintings, Twachtman described a swath of modest wildflowers in a manner that effectively removes them from the context of a clearly defined space (neither ground nor horizon is visible) and lends them a particular immediacy. The shallow space in turn serves to emphasize the richly textured paint surface and the subtly animated pattern of the brushwork. Twachtman described the full, heavy blooms with controlled, impastoed touches on the heavy canvas, whose pronounced horizontal weave contributes to the vague sense of motion from side to side. His sensitivity to such effects is apparent in a letter that he wrote in the early autumn of 1892, quite possibly while he was engaged in painting this work: "The foliage is changing and the wildflowers are finer than ever. There is greater delicacy in the atmosphere."[1] The dissolving haze of color links this work to the artist's floral subjects in the pastel medium, whose powdery texture he appears to have mimicked in the surface of this work.

Meadow Flowers was purchased from the artist's widow in 1908 by William T. Evans, an Irish-born businessman and avid collector of American art who amassed a significant collection of American Impressionist canvases, which eventually included twenty-one works by Twachtman.

1. John H. Twachtman to Julian Alden Weir, September 26, 1892, Weir Family Papers, MS 41, Archives and Manuscripts, Harold B. Lee Library, Brigham Young University, Provo, Utah, as quoted in Richard J. Boyle, *John Twachtman* (New York: Watson-Guptill Press, 1979), 52.

Julian Alden Weir

(August 30, 1852–December 8, 1919)

Willimantic Thread Factory, 1893

Oil on canvas, 24 × 33⅝ inches (61 × 85.4 cm)
Signed lower left: "J. Alden Weir—93"
16.30, John B. Woodward Memorial Fund

One of a handful of paintings by J. Alden Weir set in the industrial mill town of Willimantic, Connecticut, *Willimantic Thread Factory* offers an unusual variation on the favorite American Impressionist theme of the sunlit New England landscape. Located east-southeast of Hartford, where the Willimantic and Natchaug rivers meet to form the Shetucket, Willimantic had blossomed as a textile center during the War of 1812, and its factories expanded and multiplied in succeeding decades and particularly in the 1890s, when major railway connections were established. Weir began painting Willimantic in 1893, during summer visits with the family of his late wife in nearby Windham, where he was courting her sister Ella at the time.

Weir's representation of Willimantic offered a literally and metaphorically bright view of the mill town as a sort of brilliant city on a hill, with the mill framed as a modern civic center buttressing the hillside dotted with rooftops and steeples. His characterization of this massive yet soberly designed work of New England architecture is unadulterated by any suggestion of the drudgery that it housed or the substantial labor unrest that occurred there at the time. The rolling New England landscape that fills the lower half of the painting correspondingly seems unchanged by the presence of industry, and the blue-gray plumes of smoke that rise from the factory wing at the left appear no more threatening than the clouds in the pale blue sky. Weir enhanced the scene's bright mood with his use of light, clear tones and a lively, sketchy paint application throughout the canvas.

Daniel Ridgway Knight

(March 15, 1839–March 9, 1924)

The Shepherdess of Rolleboise, 1896

Oil on canvas, 68 × 50½ inches (172.7 × 128.2 cm)
Signed lower right: "Ridgway Knight / Paris 1896"
98.14, Gift of Abraham Abraham

Trained in Paris, Daniel Ridgway Knight remained an expatriate in France and established his reputation with idealized peasant subjects set in the rural countryside. In *The Shepherdess of Rolleboise*, his entry in the Paris Salon of 1896, Knight achieved the imposing form, delicate expression, refined surface, and silvery palette that distinguish his mature work. Knight probably began to focus on single-figure subjects about 1889, under the strong influence of the immensely popular French academic painter Jules Breton, whose peasant figures were characterized by a lyrical monumentality. He increasingly designed more effectively resolved compositions of gracefully imposing country girls set before backdrops of moody, atmospheric landscapes. If Knight's late figures are more pensive than the subjects of his early canvases, they remain free of any disturbing hint of class-based discontent. Owing to an emphasis on physical delicacy and an almost sentimental attention to the humble details of the costumes in which he clothed his models, his figures are only distant relations of Breton's peasants, whose heavy proportions and rough features convey the strains of agrarian life.

While taking compositional cues from Breton, Knight retained the refined draftsmanship that he had perfected at the École des Beaux-Arts, and in the atelier of Charles Gleyre in particular. This quality is especially apparent in the exquisite outline and delicate modeling of the head and ruddy hands. Looking to an additional source, he derived the broader touch employed in the description of the tattered clothing and foreground details, as well as the palette of silvery greens and browns, from the more stylistically progressive work of Jules Bastien-Lepage.

The Shepherdess of Rolleboise was presented to the Brooklyn Museum by the collector and Brooklyn Museum trustee Abraham Abraham just two years after its completion.

Abbott Handerson Thayer

(August 12, 1849–May 29, 1921)

My Children, circa 1896–1910

Oil on canvas, 48¹⁄₁₆ × 60⅜ inches (122.1 × 153.3 cm)
Inscribed upper right: "Painted By Me / Abbott H. Thayer / about 1900 / Finished Dec. 1, 1910 / or rather touched again"
68.158.2, Dick S. Ramsay Fund

A leading figure painter of the American Gilded Age, Abbott Handerson Thayer was most noted for his idealized visions of womanhood. He prepared this canvas, in which the theme is fully in play, in the course of creating a memorial to the writer Robert Louis Stevenson (1850–1894), employing his own three children as models (Mary, flanked by Gladys on the left and Gerald on the right). Thayer had already begun a larger version (Smithsonian American Art Museum, Washington, D.C.) in 1893, and he probably undertook this work in accordance with his practice of painting (or having studio assistants paint) copies to "preserve" the look of a canvas at a certain point in its development. His homage to the writer eventually took the form of one of his classically garbed winged figures, *Stevenson Memorial*, 1903 (Smithsonian American Art Museum, Washington, D.C.).

My Children reveals Thayer's pictorial concerns of the early 1890s, when he began to portray monumentalized figures in formal compositions recalling Italian Renaissance altarpieces. Bridging the religious and the secular, these paintings echoed the iconography of the Virgin Mary as recast according to Thayer's notion of the ideal of American womanhood—itself shaped by the Neoplatonic writings of Ralph Waldo Emerson. Thus, although Thayer's iconography recalls Christian imagery, elements such as the laurel wreath in Mary's hands, her classicized drapery, and the phantom wings formed by the contours of foliage against sky align her just as strongly with the Greek goddess Athena-Nike. These images ultimately present Thayer's vision of the human spirit at its noblest: the expression of love, strength, and beauty embodied in the ideal and eternal feminine.

The constant issue of what Thayer considered "finished" is particularly critical with respect to this canvas. Although portions of the painting are merely roughly sketched, his inscription indicates that he had completed work on it. Moreover, the original elaborate Italianate frame and the sale of the painting during Thayer's lifetime confirm that the artist was willing to allow the work to stand for itself.

Frederick Childe Hassam

(October 17, 1859–August 27, 1935)

Late Afternoon, New York, Winter, 1900

Oil on canvas, 36¹⁵⁄₁₆ × 29 inches (93.8 × 73.7 cm)
Signed lower left: "Childe Hassam 1900"
62.68, Dick S. Ramsay Fund

Childe Hassam's most significant contributions to American art were the New York street scenes that offered his American audience a native equivalent of French Impressionist views of Paris. He first revealed his attraction to urban subjects in a number of Boston views from the mid-eighties, when he experimented with the pictorial possibilities of sweeping urban avenues, city traffic, and architecture enveloped in the tints of time and weather. By the time he painted *Late Afternoon, New York, Winter,* after an extended period of work in Paris, he was a confirmed Impressionist devoted to contemporary subject matter, visual accidents, and evanescent effects. In such increasingly decorative city views from about 1900, Hassam offered a more romanticized image of turn-of-the-century New York, with little trace of the grittiness that characterized the rendering of urban subjects in the Realist literature of the period.

Hassam executed *Late Afternoon, New York, Winter* with a particularly fine Impressionist touch and a delicately limited palette, achieving the decorative unity and evocative sense of place, time, and atmosphere that characterize his best late cityscapes. Here his choice of site and his treatment of it reveal only aesthetic concerns. The locale (the north side of Central Park South, looking east from near Seventh Avenue) was an area where the urban poor customarily were not seen; he included a few figures rendered only as shadowy shapes. Hassam described his primary subject, the architectural streetscape dematerialized by the screen of driving snow, with thin layers of long strokes applied over and around summarily suggested forms. He accented the predominantly blue tonality of the tapestry-like surface with the effects of light shining from the windows here and there. A picturesque handful of private horse-drawn cabs—which already were becoming increasingly rare—make slow progress along the street, whose snow-covered edge is marked by the slight trees and street lamps. In its lyrical tonalism, suppressed detail, and muted narrative, this canvas is among the most Whistlerian efforts in Hassam's oeuvre.

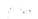

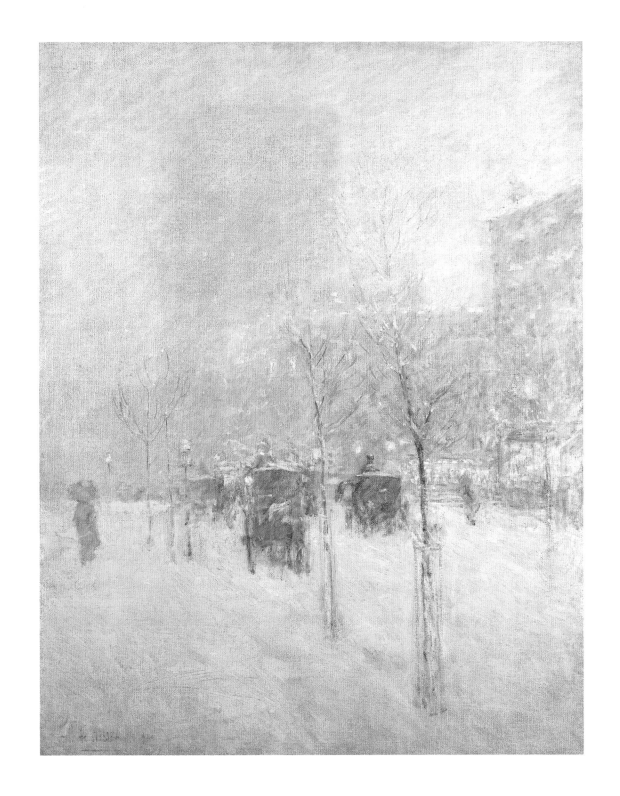

William J. Glackens

(March 13, 1870–May 22, 1938)

East River Park (formerly *Park on the River*), circa 1902

Oil on canvas, 25³⁄₁₆ × 31³⁄₈ inches (64.6 × 80.4 cm)
Signed lower right in cursive: "W. Glackens"
41.1085, Dick S. Ramsay Fund

One of the young Realists who exhibited in 1908 as The Eight, William Glackens debuted on the New York art scene with gritty urban subjects including *East River Park*, in which his stylistic debt to the French Realist Édouard Manet is strikingly apparent. After painting French parks and quays in the mid-1890s, Glackens turned his focus to the American equivalents of such unembellished settings for modern urban leisure. These sites included a handful of Manhattan waterside parks that had largely escaped the attention of the American Impressionists, who had far preferred the bucolic reserves of Central and Prospect parks as subjects for their pretty and decoratively arranged canvases.

Here Glackens featured East River Park (established about 1887 on a narrow strip bordering East End Avenue from Eighty-fourth to Ninetieth streets and now known as Carl Schurz Park), which commanded a direct view of the burgeoning industrial development on the westernmost tip of Long Island. At the time, he clearly was drawn to such instances of the ironic confluence of leisure and industry at the city's margins—a theme first explored by the French Impressionists. The figures (whose effective characterizations owe something to Glackens's experience as a quick-sketch artist) belong to a less-privileged class than those who frequented the meadows and merry-go-round of Central Park. At home in the setting, they appear oblivious to the bustling, smoggy backdrop.

Glackens painted the scene rapidly and intuitively (and directly over a previous image). He organized the composition around the sweeping and slightly tilted stretch of promenade, linking its various components by means of the dark, assertive forms of the cropped trees, which lend the painting a two-dimensional emphasis. His broad execution is particularly free in the background, where the ships and steamers, and the curling plumes rising from the factory stacks, animate the setting. In his subsequent park subjects, Glackens sought the calmer reserves of Central Park and quite deliberately omitted the pressing sense of the city's rougher outer edges.

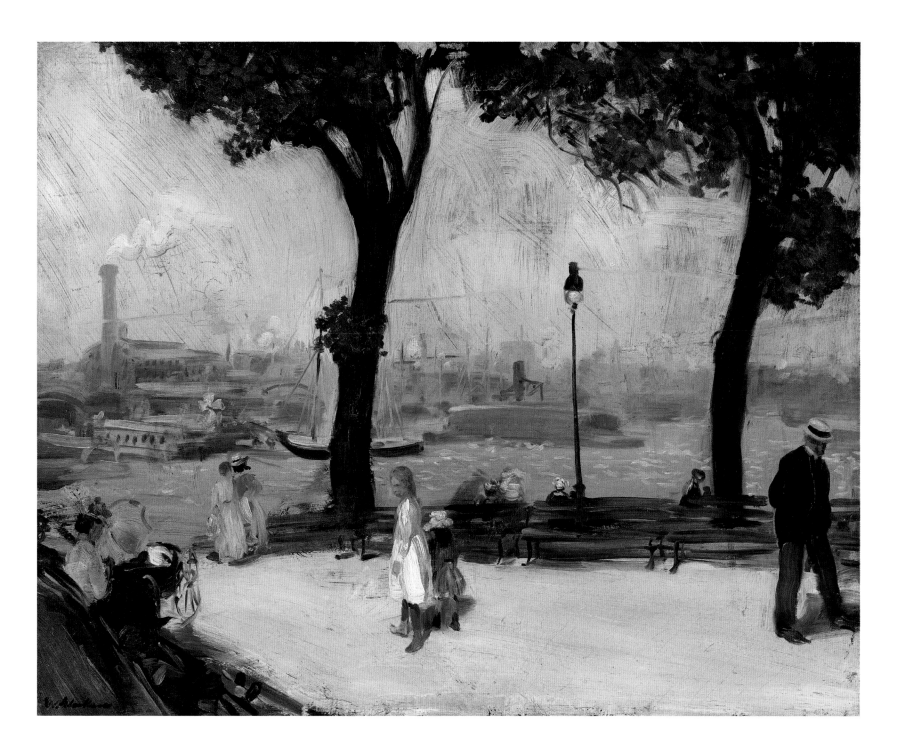

John White Alexander

(October 7, 1856–May 31, 1915)

Memories, 1903

Oil on canvas, 61¹⁄₁₆ × 52¹⁄₁₆ inches (157.7 × 132.3 cm)
Signed lower left: "John W. Alexander / '03"
22.75, Museum Collection Fund

As a resident in Paris throughout the 1890s, the American painter John White Alexander entered the refined, cosmopolitan milieu of the French Symbolists and, under their influence, dramatically transformed his own aesthetic. In *Memories*, completed two years after his return to the United States, both his subject and its treatment reveal the depth of the ongoing Symbolist influence on his work. The theme of idealized women in a state of reverie, intuiting spiritual and mystical sources, was central to Symbolist imagery, as were the sinuous, flowing lines that became Alexander's own stylistic hallmark. Here motif and style converge to evoke a languor and somnolence, couched in the setting of an indeterminate landscape. The facial expression of the woman at the left calls forth the notion of the dream state, a primary motif in both Pre-Raphaelite and Symbolist imagery. The detail of the closed book in the hand of her companion reiterates a temporary abandonment of the conscious state.

Alexander's figure paintings were fundamental in introducing this iconography to the mainstream of American art.

Throughout his career Alexander was especially attentive to the materials of his craft, here employing one of his preferred techniques of a dry brush on a roughly woven French linen to achieve a heavy texture. The work is also characterized by his distinctive and harmonious color transitions and pervasive softness of line.

Memories was among the last of Alexander's suggestively sensual subjects. His departure from this vein, accompanied by his retreat from a highly decorative aesthetic, has been interpreted as the artist's rejection of a cosmopolitan vernacular in response to the emerging climate of nationalism in America at the time. The picture was widely exhibited during the artist's lifetime and often praised for its fine technique and expression of beauty.

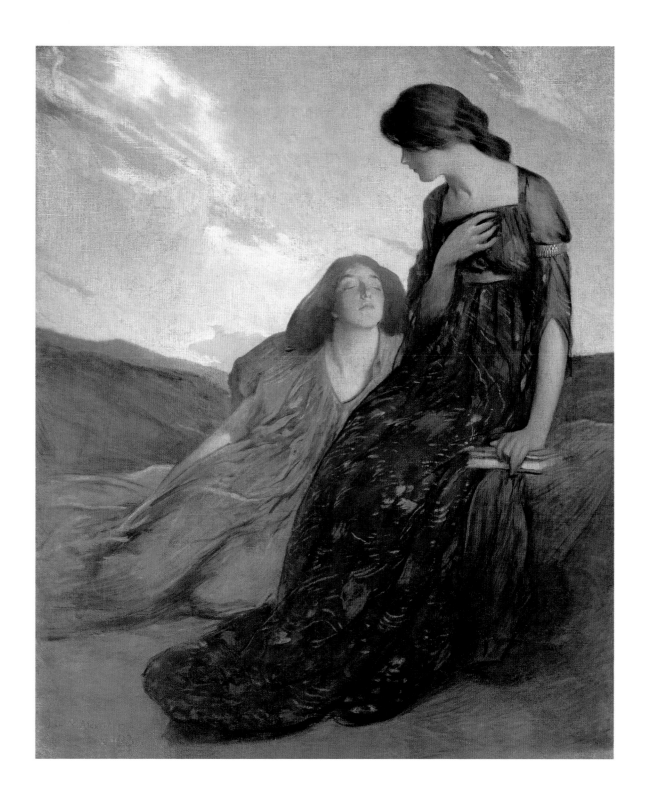

George Luks

(August 13, 1866–October 29, 1933)

Street Scene (Hester Street), 1905

Oil on canvas, 25¹³/₁₆ × 35⅞ inches (65.5 × 91.1 cm)
Signed lower right: "George Luks"
40.339, Dick S. Ramsay Fund

One of the dynamic American Realists known as The Eight, George Luks was a tough character who in art and life embraced the gritty side of turn-of-the-century New York. In this important early work, Luks offered one of his most fully developed narratives on the street life of the Lower East Side's teeming immigrant neighborhoods. By 1905 Hester Street (running east-west from East Broadway to Centre Street, one block above Canal Street) had become home to a population of recently arrived Eastern European Jews and the site of a daily open-air market where thousands of poor urban dwellers sought all their necessities. Hester Street provided the type of unvarnished, chaotic urban subject to which Luks was particularly drawn, and one from which New Yorkers accustomed to genteel shops and formal public etiquette would have recoiled. At the same time, such subjects held a certain exotic appeal for those intrigued by how the other half lived. They were rendered palatable by Luks's essentially benign treatment—free of painfully realistic details, as well as the harsh cultural typing and the grating social agendas he employed in his confrontational illustrations.

As was his practice, Luks probably executed on-site sketches before beginning work on the painting. Once begun, however, he completed it with rapid spontaneity, working out the compositional details directly on the canvas. The exceedingly sketchy quality of his execution reinforces the sense of the incessant activity of the dense crowd, set against the backdrop of tenement buildings. The most directly expressive figures in the scene are the voluble poultry vendor at the right, and the solitary smoker at the left, who introduces the persona of the observer. Luks debuted *Street Scene (Hester Street)* in 1908, when it was included in the famous Macbeth Galleries exhibition of The Eight.

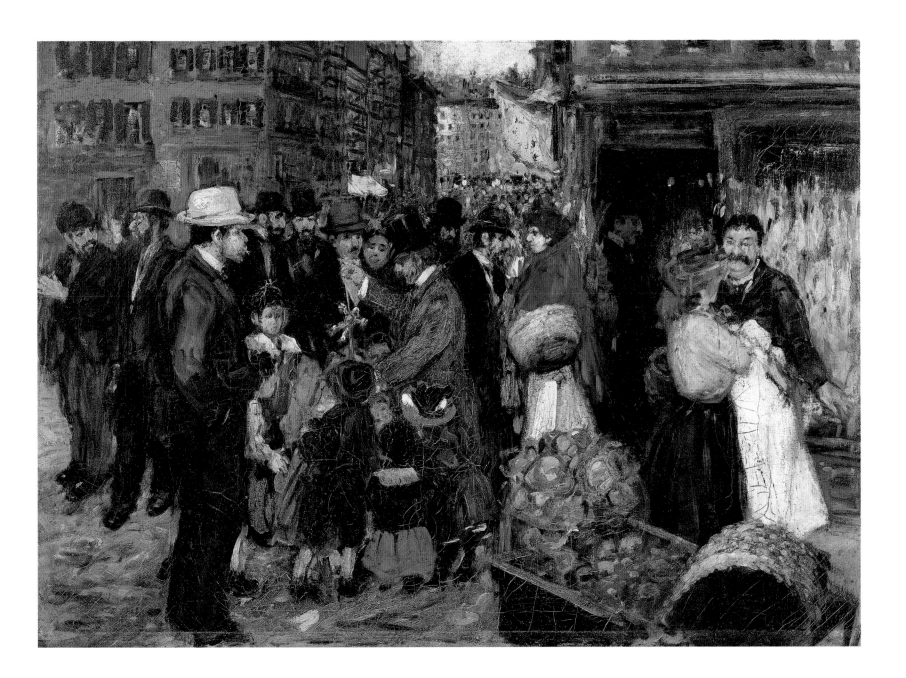

John Sloan

(August 2, 1871–September 7, 1951)

The Haymarket, Sixth Avenue, 1907

Oil on canvas, 26⅛ × 34¹³⁄₁₆ inches (66.3 × 88.5 cm)
Signed lower right: "John Sloan .07"
23.60, Gift of Mrs. Harry Payne Whitney

As a gutsy young urban Realist in turn-of-the-century New York, John Sloan found much of his early subject matter close to home; he lived just blocks from the Tenderloin district (running from Twenty-fourth to Forty-second streets, between Sixth and Ninth avenues), a hotbed of vice known then as Satan's Circus and later described by the artist as "drab, shabby, happy, sad, and human."[1] His focus here was the Haymarket (then at Sixth Avenue between Twenty-ninth and Thirtieth streets), one of the city's most notorious dance halls and, like many of the nearby "concert saloons," a thinly disguised house of prostitution. Sloan's portrayal of the Haymarket and of other risqué urban subjects was remarkably nonjudgmental. Taking his cues from Walt Whitman's versified celebration of sensuality and Édouard Manet's images of emancipated Parisian women, he celebrated the willful independence of a certain class of urban women from the expectations of bourgeois society. Sloan judged correctly that this upbeat treatment of the subject was better suited to the tastes of the conservative American art establishment, who would have been entirely scandalized by a more factual presentation of the seamier side of the urban pageant.

As was his practice, Sloan worked the canvas rapidly, producing a sketchy and rather dark composition anchored by the bright and alluring doorway through which a stream of gaily dressed ladies passes. To the left, a working woman of a different sort, carrying a loaded basket of laundry or the like, notices the diversion of her young girl's attention to the flashy passersby. The shaded windows on the second floor very likely suggested illicit activity to viewers familiar with the place.

Sloan exhibited *The Haymarket, Sixth Avenue* in the seminal 1908 Macbeth Galleries exhibition of The Eight, where it figured among a group of similarly provocative urban themes. A critic who noted that these artists had "neglected no picturesquely ugly or disagreeable phase of metropolitan life" added that Sloan had indeed idealized his subject.[2] The importance of *The Haymarket, Sixth Avenue* in the artist's oeuvre is matched by the distinction of its earliest owner, Sloan's most ardent early patron, Gertrude Vanderbilt Whitney.

1. John Sloan, *Gist of Art* (New York: American Artists Group, 1939), 214.
2. "Academy's Show Wins High Praise," *New York Herald*, March 14, 1908, p. 10.

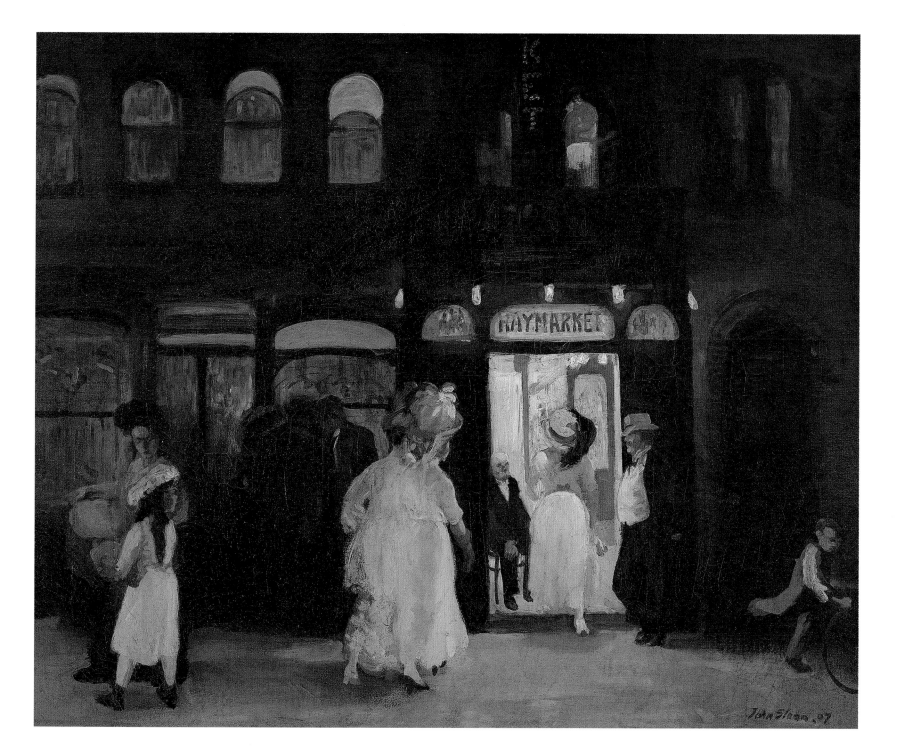

William J. Glackens

(March 13, 1870–May 22, 1938)

Girl with Apple (formerly *Nude with Apple*), 1909–10

Oil on canvas, 39⁷⁄₁₆ × 56³⁄₁₆ inches (101.2 × 144.2 cm)
Signed lower left: "W. Glackens"
56.70, Dick S. Ramsay Fund

This large studio nude painted expressly for exhibition was a highly unusual work in the context of American art of the early twentieth century, when nude subjects were more often cast within the narrative contexts of ancient mythology or symbolic allegory. In this eye-catching composition, William Glackens responded to the long tradition of daring European nudes, particularly Édouard Manet's startlingly direct *Olympia*, 1863 (Musée d'Orsay, Paris), in which that artist frankly conveyed the modernity of his model (a Parisian prostitute) and the contrived nature of the studio setting in which she was portrayed.

Glackens referred directly to the semireclining posture of Manet's model, although he differentiated his figure by adding the apple in her hand (a detail recalling the visual tradition of the temptress Eve) and by positioning a corner of cloth in place of the hand with which "Olympia" protects her dubious modesty. In quoting further from the Manet, Glackens employed such details as the dark ribbon circling his model's neck and her outward, unselfconscious gaze. He heightened the erotic effect of the piled clothing by draping the underslip on the sofa beneath her and by pointedly displaying the blue hat and shoe to reiterate her state of complete undress. In a departure from the abstracted backdrop of Manet's composition, however, Glackens chose to accentuate the familiar, domestic character of the parlor setting that served as a studio in his home on Washington Square. His execution revealed a fresh embrace of a fully Impressionist manner that most critics linked to the works of Pierre-Auguste Renoir despite the relatively few points of direct comparison. The strength of the canvas lies in Glackens's virtuoso rendering of the richly tinted whites of the figure and draperies, which are framed effectively by the more intensely colored surroundings.

Glackens debuted *Girl with Apple* in the seminal 1910 Exhibition of Independent Artists, an unjuried display open to all and intended as a venue for progressive works of art.

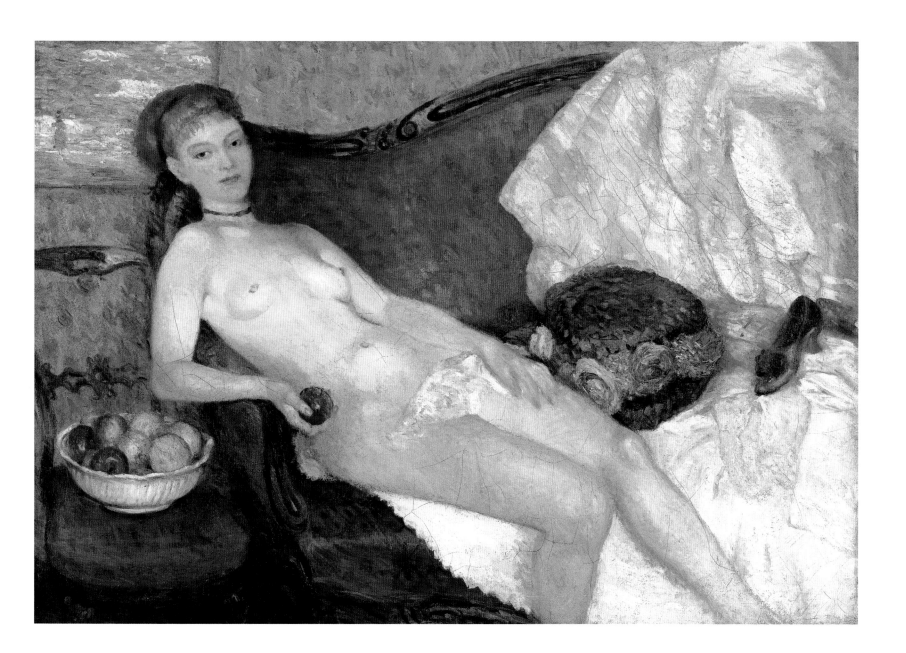

George Wesley Bellows

(August 12, 1882–January 8, 1925)

A Morning Snow, 1910

Oil on canvas, 45¹/₁₆ × 63³/₁₆ inches (114.5 × 160.5 cm)
Signed lower left: "Geo Bellows–"
51.96, Gift of Mrs. Daniel Catlin

George Wesley Bellows was a masterful Realist who based his art on both direct observation and complex theories of composition and color. *A Morning Snow* is one of a number of works in which this urban painter demonstrated his nostalgia for the relatively unspoiled edges of New York City and his eagerness to confront the compositional challenge of expansive spaces. Bellows already had recorded the rough pockets of lower Manhattan's increasingly industrial shoreline when he sought these more conventional views along the comparatively attractive Hudson riverfront in two stretches of Riverside Park above 120th Street.

By this time Bellows was beginning to experiment with more assertively structured compositions (based on ideally proportioned rectangles), as well as a more expressive application of paint. The measured arrangement of *A Morning Snow,* with its network of strong horizontals and verticals marking the spatial recession from the narrow park to the ice-covered river and New Jersey hills, asserts itself on a purely intuitive level. The view's less scenic details—a working pile driver and the steaming locomotive just visible through the trees—are relegated to the margins of the picture, where they lend an industrial accent to the predominantly natural setting. Bellows carried the assertive quality of the composition into his execution, creating a lively textured surface with brush and palette knife. He reveled in the coloristic treatment of the sunlit snow, hinting here at the exuberantly liberated palette he would employ in snow scenes by the mid-teens.

Critics praised *A Morning Snow* for its frank and upbeat Realism (which one writer described as a "healthy delight in the splendid physical world"),[1] although some found the palette too bracing and the execution excessively forceful. *A Morning Snow* appealed to the moderately progressive tastes of the German American collector Hugo Reisinger, best remembered as the head of Harvard's Germanic Museum (now the Busch-Reisinger Museum), who purchased the canvas directly from the artist.

1. "Work of Contemporary American Landscape Painters Shown at the National Arts Club," *The New York Times*, February 6, 1910, p. 14.

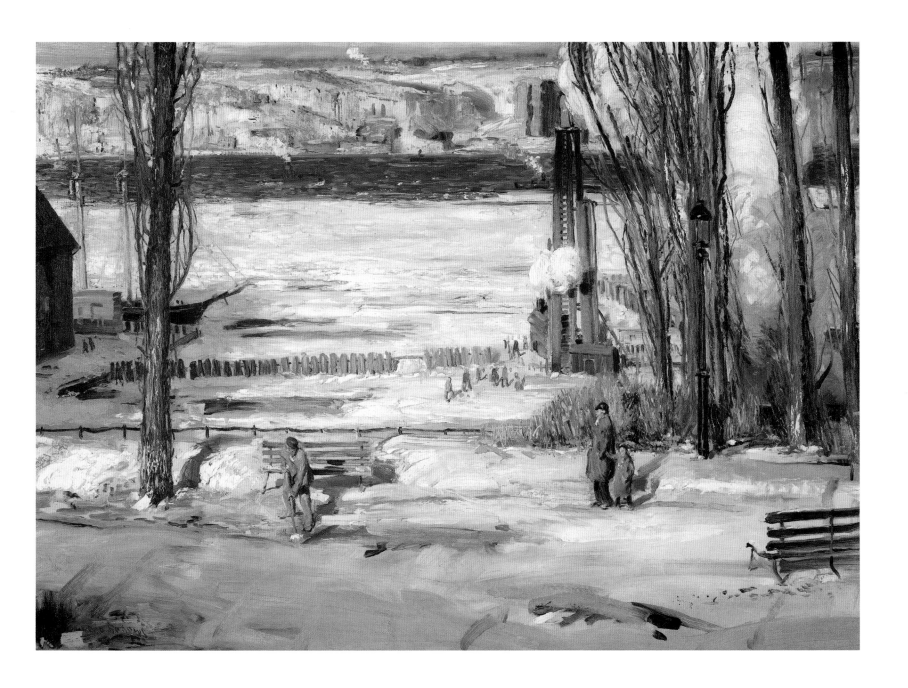

Robert Henri

(June 24, 1865–July 12, 1929)

Laughing Girl, 1910

Oil on canvas, 24⅛ × 20⅛ inches (61.2 × 51.1 cm)
Signed lower right: "Robert Henri"
12.93, Frank Sherman Benson Fund

Best known as the leader of the Ashcan School, whose proponents unflinchingly portrayed the best and the worst of turn-of-the-century New York City life, Robert Henri departed from this subject matter in his mature career to focus on rapidly executed portrait heads, especially of children. Henri's most famous works in the genre are the laughing Dutch children whom he painted during long stays in Holland, in 1907 and 1910. He found his inspiration in animated character studies by the Baroque master Frans Hals, a revered figure in the Dutch painter's native Haarlem, where Henri worked for an extended period of time. *Laughing Girl*, a particularly vibrant canvas, portrays a favorite Haarlem model, Cori Peterson, of whom Henri wrote: "I have painted over and over again a little roistering white headed, red cheeked, broad faced girl. I have done many heads of her, most of them laughing."[1]

Henri emulated the liveliness and spontaneity of Hals's characterizations of laughing children, as well as their rapid and vigorously broad paint application. He indeed attempted to complete each of these portraits in a single sitting, working directly, wet paint on wet paint. Henri sought to evoke a child's mood and energy rather than a literal likeness, thus differentiating these portrayals from the more static and serious productions of other children's portraitists of the period, and from the images of tough, street-smart kids painted by his American colleagues. Although his pictorial treatments eschewed the clichéd elements of traditional clothing typical of Dutch subjects by Americans at the turn of the century, the emphatic jollity of his sitters did reflect popular stereotypes of the Dutch character. The light mood also suggested the freedom and gaiety that Henri believed characterized life in preindustrial or rural societies. Critics often praised Henri's paintings of children for their dexterous brushwork and joie de vivre, and the canvases depicting Cori were particularly popular among collectors who relished their lighthearted expression.

1. Robert Henri, Haarlem, to his parents, July 28, 1907, box 16, folder 386, Robert Henri Papers, The Yale Collection of American Literature, Beinecke Rare Book and Manuscript Library, Yale University, New Haven, Connecticut.

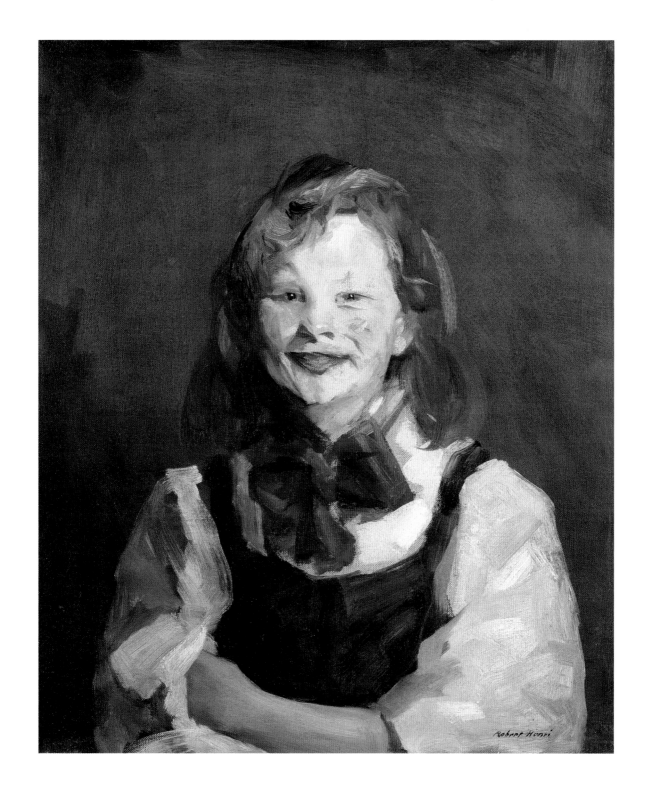

Willard Leroy Metcalf

(July 1, 1858–March 8, 1925)

Early Spring Afternoon, Central Park, 1911

Oil on canvas, 35⁵⁄₁₆ × 35⁵⁄₁₆ inches (91.3 × 91.3 cm)
Signed lower left: "W.L. Metcalf. 1911"
66.85, Frank L. Babbott Fund

Although the American Impressionist Willard Metcalf painted urban subjects only rarely, *Early Spring Afternoon, Central Park* is among his most evocative and successful canvases. Metcalf undertook the scene shortly after his marriage to Henriette McCrea and their move to a stylish apartment on the eighth floor of the Pimlico, at Sixty-ninth Street and Central Park West, from which the view was taken. Henriette Metcalf later recalled, "I remember Willard remarking that the picture he would paint from the window would pay at least a year's rent!!!"[1]

Metcalf's early urban views were inspired by the many bird's-eye city views by the French Impressionists, including Claude Monet, with whom he had spent time in Giverny during the mid-1880s, and by the numerous city subjects by his American colleague Childe Hassam. Here Metcalf adopted the type of vertically arranged perspectival view that Monet and Hassam had often employed, transforming the rolling park terrain into a decorative two-dimensional design. The serpentine roadway leads the viewer's eye to the buildings lining the east side of the park, including the green-domed, Moorish Revival Temple Beth El (then at Fifth Avenue and Seventy-sixth Street).

Literally and metaphorically painting the sunny side of the city, Metcalf cast the view in a pastel haze, rendered with a pale and airy palette that contributes to the work's decorative character. He had developed a refined Impressionist execution by this time, employing smaller, carefully placed touches of paint to enhance the formal and coloristic play of the composition. The enthusiastic critical response to *Early Spring Afternoon, Central Park* was couched in language intended to rival the painting's evocative expression. James Huneker mused at length: "The air . . . shimmers in the distance. You seem to be gazing on the shapes of some remote Eastern city, with its palaces rearing skyward, its turrets, minarets and mosque. . . . The entire picture is bathed in mystery, and it is hard to realize that it is the familiar New York. . . ."[2] Pleased with the success of the canvas, Metcalf exhibited *Early Spring Afternoon, Central Park* frequently until its sale in 1915 to the wealthy collector Cyrus Hall McCormick.

1. Henriette Metcalf to Donelson Hoopes, July 17, 1968, Curatorial File, Department of American Art, Brooklyn Museum.
2. [James Huneker], "Things Seen in the World of Art: Pictures by Willard L. Metcalf on Exhibition," *The Sun* (New York), January 7, 1912, sec. 3, p. 4.

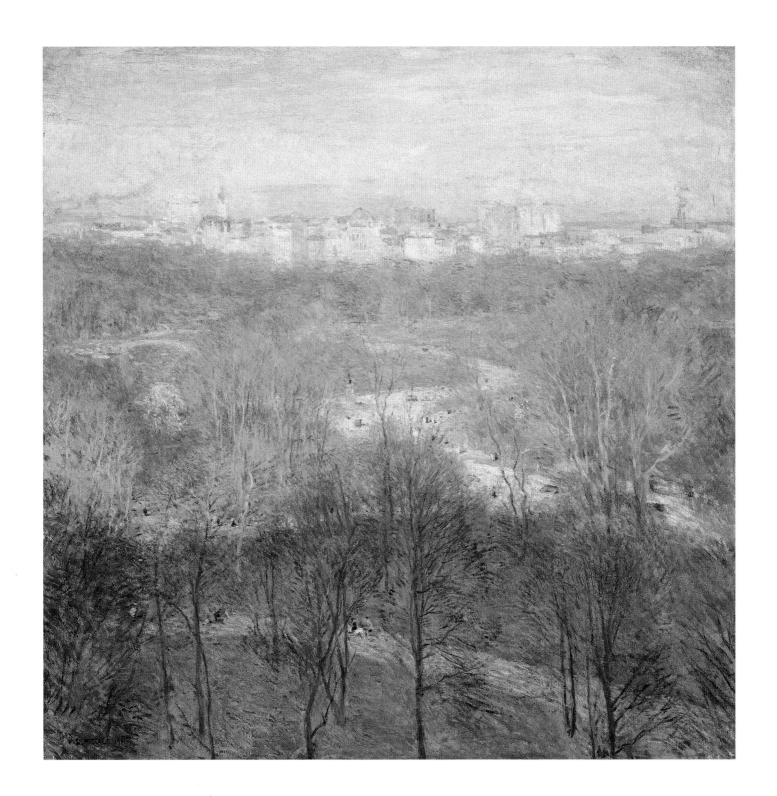

Chronology of the Collection

PART 1
American Art at the Early Brooklyn Institute

1824 Brooklynite Augustus Graham, a prominent Unitarian philanthropist, becomes a key founder of the Apprentices' Library Association, a library for working men and women, and forerunner of The Brooklyn Institute

1827 The inauguration of a lecture series moves the ALA in the direction of a lyceum, the period's primary form of egalitarian social uplift organization

1840 The ALA is reformed as The Brooklyn Institute; Graham assumes the presidency, purchases the Lyceum Building, and merges the library with the Brooklyn Lyceum

1841 Emulating British uplift organizations that were promoting arts education to further technology and commerce, the Institute establishes drawing classes

1843 Graham initiates the first of seven annual loan exhibitions of American and European paintings, manufactures, and natural history specimens; they rival the exhibitions at the National Academy of Design with works by major American painters

1844 A trustee committee solicits loans for the 1844 exhibition, stating the Institute's expanded educational goal "to diffuse a taste for the Fine Arts, and thus to patronize and encourage meritorious artists, particularly of our own country"

1845 Graham and his trustees discuss the possibility of establishing a permanent art gallery, again following the lead of British institutions that had embraced art displays for the elevation of industrial design and public taste and attitudes; as in 1843, the annual painting exhibition is dominated by American art, including the late Francis Guy's *Winter Scene*; enthusiastic reviews praise the Institute for its effort to widen the audience for the arts

1846 Francis Guy's *Winter Scene* is purchased for the Institute by a group of Brooklynites; Walt Whitman, the new, young editor of the *Brooklyn Daily Eagle*, publishes "Polishing the Common People," asserting that American life lacks the edifying force of the fine arts; Institute trustees formally announce plans for a permanent, free Gallery of Art and solicit works; in his review of the annual exhibition, Whitman similarly calls for the creation of a permanent, free gallery of art, open to all

1847 Whitman describes the Institute as "decidedly the most interesting feature of Brooklyn life"; his review of the annual exhibition praises Brooklyn artists and their potential effect on the local audience

1848 Graham provides funds to ensure the viability of the Institute and its uplift agenda

1849 The last annual exhibition is praised by the *Brooklyn Daily Eagle* (after Whitman's departure), which describes the Institute as Brooklyn's "principal source of public instruction and amusement"

1850 The first exhibition of the new Brooklyn Art Union, devoted to the promotion of works by Brooklyn artists, opens at the Institute, which has discontinued its annual exhibitions

1851 Whitman writes "Something About Brooklyn Art and Artists" (*Evening Post*), advocating the cultivation of every individual's artistic spirit to engender original American artistic expression; Whitman delivers the opening address for the Brooklyn Art Union's second annual exhibition at the Institute and promotes local art for social uplift; Augustus Graham dies, leaving $27,000 to the Institute, with $5,000 for the support of a School of Design and a Gallery of Fine Arts; influenced by Whitman's rhetoric, Graham has designated the Gallery to consist of works commissioned from living American artists, making the Institute the only institution then known to have commissioned American art for a permanent collection

1855 The Institute activates Graham's acquisition fund with commissions for works from Asher B. Durand and Daniel Huntington; Durand completes *The First Harvest in the Wilderness*, a landscape allegory and tribute to Graham; Whitman publishes *Leaves of Grass*, and in his preface he conjures an activist artist population

1858 Huntington fulfills his commission with *The Sketcher: A Portrait of Mlle Rosina, a Jewess*; the Institute meanwhile has abandoned its commitment to art, and the nascent collection founders temporarily

1867 Building renovations strain the Institute's budget; the center of Brooklyn's art scene shifts to Montague Street, home of the Brooklyn Art Association

1879 With the permanent collection numbering fifteen works, trustees acknowledge the inadequacy of the Graham bequest to support the purchase of worthy paintings and they suspend use of the funds

PART 2
American Art at the New Brooklyn Museum

1888 A Citizens' Committee calls for the organization of a Brooklyn institution equal to the resources of Manhattan's Metropolitan Museum of Art and American Museum of Natural History

1889 At The Brooklyn Institute, George Brown Goode, Assistant Secretary of the Smithsonian and a proponent of didactic displays, urges rallying founders to collect in fields not yet represented in New York

1890 The waning Brooklyn Institute is reincorporated as The Brooklyn Institute of Arts and Sciences, and former Metropolitan Museum curator William Henry Goodyear is appointed curator of Fine Arts

1897 The Brooklyn Institute of Arts and Sciences opens in a grand McKim, Mead & White building with an inaugural loan exhibition of paintings organized by collectors and trustees; trustee Abraham Abraham presents Daniel Ridgway Knight's *The Shepherdess of Rolleboise*; the display remains on view, as the "loan collection," with "antiquarian" American art segregated from contemporary paintings; the popular installations are renewed each year

1902 Trustee Robert B. Woodward creates the seminal John B. Woodward Fund (in memory of his brother, a former Institute president) for the annual purchase of recent American art

1903 Former Brooklyn mayor and trustee Charles A. Schieren loans eight works by Ralph Albert Blakelock

1904 To accommodate loans and acquisitions, Goodyear rehangs the galleries according to chronological and stylistic classifications and integrates some "historical" American paintings into the main galleries; Charles Warren Eaton's *Connecticut Pines* is the Woodward Fund purchase

1905 Goodyear's annual reinstallation absorbs a growing number of purchases and gifts; Edwin Lord Weeks's *The Hour of Prayer at the Pearl Mosque, Agra* is given by the Brooklyn collector and trustee George D. Pratt

1906 The Museum receives the late Brooklyn philanthropist Caroline Herriman Polhemus's painting collection, including fine American cabinet pictures; funds are raised to purchase James McNeill Whistler's *Miss Florence*

Leyland; a landmark ninety paintings (American and European) are added to the collection

1907 Goodyear engineers a comprehensive reinstallation, doubling the space and creating separate American paintings rooms for the 45 historical pictures and 113 "modern" works; Elliott Daingerfield's *Midnight Moon* is the Woodward Fund purchase

1908 Edward Redfield's landscape *February* is the Woodward Fund purchase; George D. Pratt presents Frederick A. Bridgman's orientalist *An Interesting Game*

1911 The leading American art collector George A. Hearn presents five oils, including J. Alden Weir's *The Flower Seller*; gifts include John Singer Sargent's *Dolce Far Niente*; the Museum purchases five paintings from the John La Farge estate

1912 American purchases move in a progressive direction with the acquisition of Robert Henri's *Laughing Girl*; American art collector William T. Evans presents Elihu Vedder's mural study *Rome Representative of the Arts*

1913 Mary Block de Silver presents paintings collected by her late husband, trustee Carll H. de Silver, including William Merritt Chase's *Studio Interior*; a major gift from trustee Charles A. Schieren includes works by Ralph Blakelock and Arthur B. Davies; Museum members purchase George Inness's *On the Delaware River*; John Twachtman's *Meadow Flowers* is purchased out of the William T. Evans collection sale; William Henry Fox is appointed chief curator

1914 The Brooklyn Institute of Arts and Sciences is subdivided; Fox is appointed director of the independent Brooklyn Museum; with the support of Institute president A. Augustus Healy, Fox designates the fine arts as the institution's focus; Fox reconceives the galleries with a modernized design and a single row of a select group of works hanging throughout alcoves; six Albert Pinkham Ryder paintings are purchased from Cottier and Company, London, and authenticated by the artist; trustee George D. Pratt presents two canvases by Theodore Robinson

1915 Fox focuses collection building and exhibition work on contemporary American art; the Museum opens the acclaimed invitational exhibition *Contemporary American Paintings* and purchases seven entries, including

Hayley Lever's *Winter, St. Ives*; Charles A. Schieren's bequest includes seven Blakelocks; the Museum garners attention for exhibiting John Singleton Copley portraits, including a recent purchase

1916 The Museum accommodates a dual interest in contemporary and early American painting, with the latter agenda initiated by trustees

1917 Trustees John Hill Morgan and Walter Crittenden organize the seminal exhibition *Early American Painting*; Morgan is charged with shaping the early American holdings; the Museum opens *Works of American Painters, 1860–1885: A Special Exhibition to Celebrate the Opening of the Catskill Aqueduct* to complement the Metropolitan's Hudson River School exhibition marking the Catskill Aqueduct opening

1918 The Museum receives two works by Walter Libbey, the Brooklyn painter championed by Walt Whitman

1920 The Museum hosts the National Academy of Design annual exhibition; Fox purchases John Singer Sargent's *An Out-of-Doors Study*

1921 The Museum purchases Theodore Robinson's *The Watering Pots*, formerly owned by new Institute president Frank L. Babbott

1922 Trustee Walter Crittenden supports Fox's contemporary art agenda and presents John Singleton Copley's *Mrs. Alexander Cumming*

1923 Morgan arranges the purchase of Charles Willson Peale's *Mrs. David Forman and Child*; Mrs. Harry Payne Whitney presents John Sloan's *The Haymarket, Sixth Avenue*

1924 An exhibition of American holdings marks the Institute's centennial; the decade's most adventurous American purchase is George Bellows's *The Sand Team*; Morgan's early American purchases continue with Raphaelle Peale's *Still Life with Cake*

1925 Staff artist Herbert B. Tschudy replaces the late Goodyear as curator; Fox organizes *Paintings in Oil by American and European Artists*, including works by the young Stuart Davis

1926 Fox's *Paintings by Modern French and American Artists* features fifty works by Arthur B. Davies lent by Lizzie Bliss; Fox hosts the *International Exhibition of Modern Art*, a showcase for avant-garde artists of the Société Anonyme; Morgan systematically assesses the early American holdings; the Museum

receives monumental Beaux-Arts murals by Robert Blum

1927 The Museum hosts an exhibition of Albert Gallatin's contemporary American collection; Fox mounts a small Georgia O'Keeffe exhibition; the Museum purchases Thomas Eakins's *Letitia Wilson Jordan*

1928 The nearly annual contemporary exhibition (from 1925 through the early thirties) *American and Foreign Artists* includes Joseph Stella's *New York: The Voice of the City of New York Interpreted* (The Newark Museum, New Jersey); the Museum mounts an Arthur B. Davies memorial exhibition

1930 The departing Fox caps his contemporary agenda with the Woodward Fund purchase of Bertram Hartman's *Trinity Church and Wall Street*

1931 Fox's efforts are rewarded with Lizzie Bliss's gift of five Davies paintings

1932 Participating in the trend of inventive American painting survey exhibitions, the Museum mounts *Paintings by American Impressionists and Other Artists of the Period, 1880–1900*; Crittenden selects Winslow Homer's *In the Mountains* for the collection; the nineteenth-century American holdings are strengthened by the Colonel Michael Friedsam bequest, which includes works by George Inness

1934 The modernist architect Philip N. Youtz succeeds Fox as director; the Museum sustains two divergent paths in American acquisitions with the Woodward Fund purchase of Katherine Dreier's nonobjective *Unknown Forces* and Morgan's selection of Charles Willson Peale's *George Washington*

1935 Youtz temporarily moves significant early American portraits to the decorative arts period rooms and briefly considers the deaccessioning of nineteenth-century American paintings to alleviate the Museum's financial straits at the height of the Depression

1936 The American galleries are reinstalled to reflect Youtz's commitment to the social history of art; Yale-trained art historian John I. H. Baur assumes Tschudy's position and mounts the contemporary exhibition *Six American Artists*; Baur begins an inventory of the paintings collection; Woodward Fund purchases include Henry Varnum Poor's *View over Nyack—Winter*

1937 Baur reinstalls the galleries, employing didactic groupings and updated design; he organizes *Leaders of American Impressionism*

1938 Baur begins to collect American Scene paintings with the purchase of

Thomas Hart Benton's *Louisiana Rice Fields* but then meets with resistance to such acquisitions from Youtz's successor, Laurance Roberts, and from trustees

1939 Baur initiates a threefold program of exhibitions, acquisitions, and deaccessions that reshapes the historic American holdings; his purchase priorities are works by forgotten nineteenth-century painters, works by major artists featured in the collection, and early American paintings; Baur achieves these through the Dick S. Ramsay Fund, named for a prominent trustee

1940 Baur outlines a collection plan, identifying American purchase funds as the means to create a major survey collection of American oils; Baur organizes the first Eastman Johnson retrospective; the artist's granddaughter presents *A Ride for Liberty—The Fugitive Slaves* and *Not at Home (An Interior of the Artist's House)*; Baur focuses on turn-of-the-century Realism with the purchase of George Luks's *Street Scene (Hester Street)* and buys Edward Hicks's *The Peaceable Kingdom* in advance of the American folk art boom; occasional modern acquisitions include Marsden Hartley's *Ghosts of the Forest*

1941 Baur's purchase of two early eighteenth-century portraits indicates his taste for decoratively simplified colonial portraits

1942 Baur opens concurrent exhibitions of paintings by William Sidney Mount and John Quidor, and purchases Quidor's *Wolfert's Will*; William T. Evans presents Reginald Marsh's *The Bowl*

1942 The galleries are closed and the collection stored as a wartime precaution; Baur purchases Blakelock's *Moonlight*

1943 Baur acknowledges surviving members of The Eight with a retrospective and purchases Everett Shinn's *Keith's Union Square*

1944 Baur co-organizes *America 1744–1944*, featuring paintings, objects, and costumes in domestic vignettes

1945 Trustees overrule Baur's objections to purchase the Gilbert Stuart Lansdowne portrait of George Washington from Brooklyn's Pierrepont family; the Museum hosts *The Negro Artist Comes of Age*

1946 Baur reopens the galleries and mounts an exhibition of Theodore Robinson paintings; he focuses on acquisitions of mid-nineteenth-century American landscape and opens a George Inness exhibition

1947 Baur anticipates the market for the so-called Luminists with the purchase

of works by Martin Johnson Heade and Fitz Hugh Lane

1948 Baur organizes *The Coast and the Sea: A Survey of American Marine Painting*; he opens the first retrospective of the still-life painter John F. Peto and purchases *Door with Lanterns* from the artist's daughter; Baur's acquisitions spur gifts including John Quidor's *The Money Diggers* and Charles Deas's *Prairie on Fire*, both from Alastair Bradley Martin

1949 Baur purchases Washington Allston's *Italian Shepherd Boy* through a partial exchange of minor works from the collection; Baur makes a rare contemporary acquisition with the Woodward Fund purchase of Charles Sheeler's *Incantation*

1950 Focused on collection refinement, Baur employs the only Whistler portrait as a deaccession in a partial exchange for Thomas Eakins's *Home Scene*

1951 Baur takes a leave to prepare the exhibition and book *Revolution and Tradition in Modern Art*, redirecting his focus to the twentieth century

1952 With his acquisitions agendas fulfilled and the historic American collection dramatically enriched, Baur departs for the Whitney Museum of American Art

1955 Baur's successor, John Gordon, outlines his purchase priorities in the contemporary field, with digressions only for major historical works; Gordon purchases Arthur Dove's *Flat Surfaces* and two Civil War–era canvases by James Hamilton

1956 Gordon purchases William Glackens's *Girl with Apple*, previously sought by Baur

1957 Gordon organizes *Face of America: The History of Portraiture in the United States*

1959 Gordon departs and assistant curator Hertha Wegener reinstalls a selection of American works on white walls with a new system of labels

1961 Axel von Saldern, an archaeologist and art historian, is appointed curator of paintings; he organizes *The Nude in American Painting*

1962 Von Saldern initiates his impressive purchases with Childe Hassam's *Late Afternoon, New York, Winter*

1963 The acquisition of Frederic Church's *Tropical Scenery* indicates the critical resuscitation of the Hudson River School

1964 The Museum exhibits works from the collection of Daniel and Rita Fraad

1965 Succeeding von Saldern, painter and curator Donelson Hoopes focuses on highly selective but wide-ranging acquisitions, beginning with John Singleton Copley's portrait of Mrs. Sylvester Gardiner and Francis A. Silva's *The Hudson at Tappan Zee*; the Fraads present three works, including George Bellows's *Red-Faced Boy Smiling, "Jimmy Flannigan" No. 2*

1966 Hoopes purchases Willard Metcalf's *Early Spring Afternoon, Central Park* and Alexander Pope's *Emblems of the Civil War*

1967 Under director Thomas Buechner, Hoopes opens a seminal Paintings Study Gallery, a study-storage facility soon closed owing to a city fiscal crisis; Hoopes's purchases include Thomas Cole's *A Pic-Nic Party* and George Bellows's *Pennsylvania Station Excavation*; a bequest from Laura L. Barnes (wife of Albert C. Barnes) includes paintings by William Glackens; Hoopes and von Saldern organize the seminal exhibition *Triumph of Realism*, a survey of European and American Realism

1968 Hoopes's last purchases include William Merritt Chase's *The Moorish Warrior*

1973 Several American galleries are reconfigured as pathways of freestanding painting screens labeled for a novice audience

1974 Linda Ferber assumes responsibility for the American collections

1975 Ferber participates in a collaborative reinstallation of fine and decorative American art

1976 Albert Bierstadt's monumental *A Storm in the Rocky Mountains, Mt. Rosalie* is purchased through a partial exchange of works from the collection

1979 Will Low's *Love Disarmed* is purchased in conjunction with the seminal Brooklyn exhibition *The American Renaissance, 1876–1917*

1984 Formation of a separate contemporary art department circumscribes the pre-1945 American holdings; purchases including Robert Weir's *Embarkation of the Pilgrims* keep pace with academic revisionism

1985 Ferber organizes *The New Path: Ruskin and the American Pre-Raphaelites*; the presentation of Childe Hassam's *Poppies on the Isles of Shoals* continues the Pratt family's century-long tradition of giving

1990 The Museum hosts an Albert Pinkham Ryder retrospective and *Facing History: The Black Image in American Art*

1991 *Albert Bierstadt: Art and Enterprise*, co-curated by Ferber, opens; art dealer Antoinette Kraushaar wills her childhood portrait by George Luks to the collection

1992 The Museum receives a major gift of early modernist paintings from the collection of Edith and Milton Lowenthal; Isabella Kurtz presents Eastman Johnson's life-size portrait *Winter, Portrait of a Child*; the Museum hosts *Painters of a New Century: The Eight and American Art*

1993 The Museum acquires *John Jacob Anderson and Sons, John and Edward* by the African American portraitist Joshua Johnson

1995 The Museum hosts *Thomas Cole: Landscape into History*

1996 *Thomas Wilmer Dewing: Beauty Reconfigured*, co-curated by Barbara Dayer Gallati, opens; portraits by Samuel Waldo of Augustus Graham's business partner David Leavitt and his wife are given by the sitters' descendants

1999 *Eastman Johnson: Painting America*, co-curated by Teresa A. Carbone, opens; the dealer Max R. Schweitzer presents Cecilia Beaux's *Mrs. Robert Abbe*

2000 *William Merritt Chase: Modern American Landscapes, 1886–1890*, curated by Barbara Dayer Gallati, opens

2001 The Museum opens phase one of the Luce Center for American Art with *American Identities: A New Look*, a dense, thematic installation of fine and decorative arts, including Native American, Spanish colonial, and contemporary art from the permanent collections

2004 *Great Expectations: John Singer Sargent Painting Children*, curated by Barbara Dayer Gallati, opens

2005 The Museum opens phase two of the Luce Center with its Visible Storage • Study Center, housing 1,500 additional collection objects in a rich display

Bibliographical Note

For extensive information on each of the works featured in this volume and all of the historic American oil paintings in the Brooklyn Museum, refer to Teresa A. Carbone, *American Paintings in the Brooklyn Museum: Artists Born by 1876*, with contributions by Barbara Dayer Gallati and Linda S. Ferber; technical entries by Ruth E. Seidler, with contributions by Kenneth Moser, Carolyn Tomkiewicz, and Richard Kowall, 2 vols. (New York and London: Brooklyn Museum in association with D Giles Limited, 2006). In addition to full artists' biographies, the reader will find detailed discussions regarding the production and significance of individual paintings, as well as technical analyses, provenance and exhibition histories, and bibliographies. The catalogue also includes an introduction containing a full collection history, from which the chronology in this volume is drawn.

For additional general reading in the field of historic American art, the following are recommended:

Baigell, Matthew. *A Concise History of American Painting and Sculpture.* Rev. ed. New York: Icon Editions, 1996.

Bjelajac, David. *American Art: A Cultural History.* New York: Harry N. Abrams, 2001.

Craven, Wayne. *American Art: History and Culture.* Madison, Wisconsin: Brown and Benchmark, 1994.

Doss, Erika. *Twentieth-Century American Art.* Oxford and New York: Oxford University Press, 2002.

Groseclose, Barbara S. *Nineteenth-Century American Art.* Oxford and New York: Oxford University Press, 2000.

Pohl, Frances K. *Framing America: A Social History of American Art.* New York: Thames and Hudson, 2002.

Index